GEORGIA O'KEEFFE'S
Hawai'i

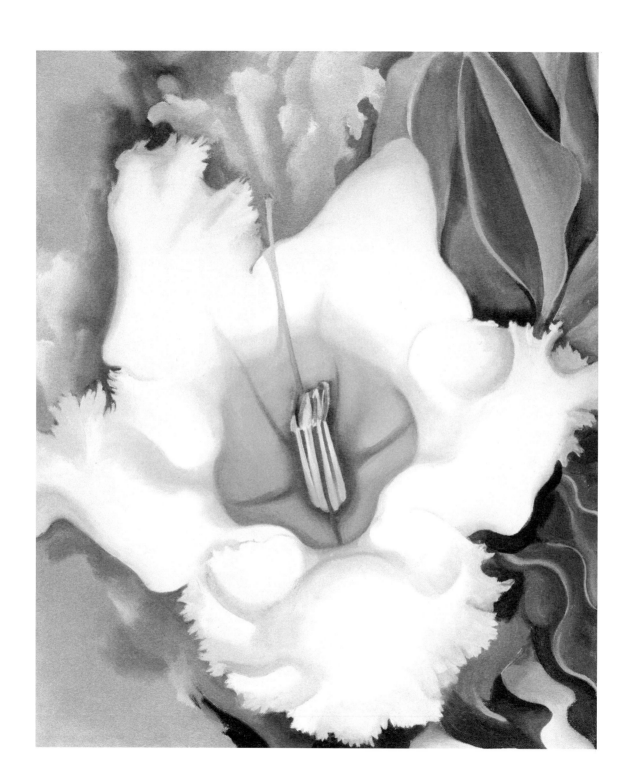

GEORGIA O'KEEFFE'S
Hawai'i

PATRICIA JENNINGS
AND MARIA AUSHERMAN
Introduction by Jennifer Saville
Afterword by James Meeker

Koa Books
PO Box 822
Kihei, Hawai'i 96753
www.koabooks.com

Publisher Cataloguing-in-Publication

Jennings, Patricia, 1926-

Georgia O'Keeffe's Hawai'i / Patricia Jennings and Maria Ausherman ; introduction by Jennifer Saville ; afterword by James Meeker. — Kihei, Hawai'i : Koa Books, c2011.

p. ; cm.

ISBN: 978-1-935646-10-5 (cloth) ; 978-0-9821656-4-5 (pbk.)
Reproduces O'Keeffe's 20 Hawai'i paintings, plus 50 period and locational photographs.
Includes bibliographical references and index.

1. O'Keeffe, Georgia, 1887-1986—Knowledge—Hawai'i. 2. O'Keeffe, Georgia, 1887-1986—Criticism and interpretation. 3. Hawai'i—In art. 4. Hawai'i—Pictorial works. I. Ausherman, Maria Elizabeth. II. Saville, Jennifer. III. Meeker, James (James J.), 1935-

ND237.O5 J46 2011
759.9/969--dc22 1110

Special thanks to the Atherton Family Foundation and the LEF Foundation for their generous support toward the publication of this book

Cover
Heliconia, 1939
Oil on canvas
19 x 16 in. (48.3 x 40.6 cm)
Private collection
© Georgia O'Keeffe Museum

Preceding page
Cup of Silver Ginger, 1939
Oil on canvas
19 1/8 x 16 1/8 in. (48.3 x 40.6 cm)
The Baltimore Museum of Art:
Gift of Cary Ross, BMA 1940.122
© Georgia O'Keeffe Museum

koa books

TIME

February 12, 1940

PINEAPPLE FOR PAPAYA

Least commercial artist in the U. S. is probably lean Georgia O'Keeffe, who paints in luminous colors skulls, flowers, feathers, barns and New Mexico. Last winter Hawaiian Pineapple Co. Ltd. (Dole pineapple) plucked up its courage, asked Artist O'Keeffe to go to Hawaii and paint two pictures for it. She agreed, on condition that she could paint whatever she pleased.

In Hawaii Artist O'Keeffe happily painted fishhooks, tropical flowers, lava bridges, waterfalls—but nary a pineapple. To Dole on her return she presented a vivid red canvas of crab's claw ginger, a lush green papaya tree (Dole's rival is papaya juice).

Tactful Art Director Charles Coiner of N. W. Ayer (Dole advertising agency) took a hand, spouted to Painter O'Keeffe about the beauty of pineapples in bud, urged her to give the pineapple a break. He phoned Honolulu, had a budding plant put aboard the Clipper. Thirty-six hours later the plant was delivered to the O'Keeffe studio in Manhattan. "It's beautiful. I never knew that," exclaimed Artist O'Keeffe. "It's made up of long green blades and the pineapple grows in the centre of them." She promptly painted it, and Dole got a pineapple picture after all.

In Alfred Stieglitz' gallery, An American Place, last week opened the result of his wife's trip: 20 paintings, including the two for Dole. The other 18 were for sale, at prices ranging up to $4,000. Best sequence: four glowing canvases of green mountains and black rocks, each held together by thin white wisps of waterfalls. Critics agreed that Georgia O'Keeffe was still tops among U. S. woman painters, mused over her Steinesque catalogue note: "If my painting is what I have to give back to the world for what the world gives to me, I may say that these paintings are what I have to give at present for what three months in Hawaii gave to me."

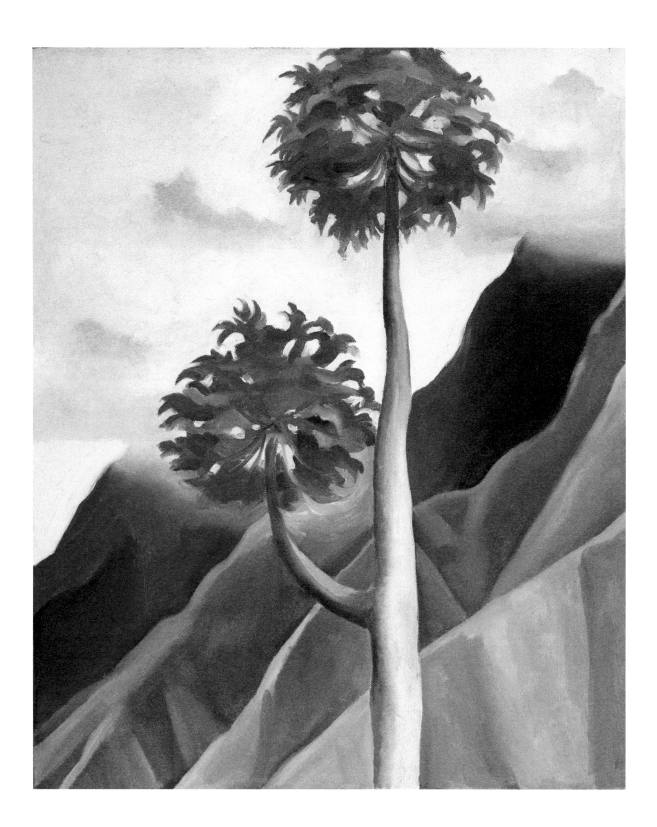

CONTENTS

I had a wonderful time out on the islands and loved it—Yes I worked—it is beautiful for painting as they have everything—almost tropics—fourteen or fifteen thousand foot mountains—bare lava more wicked than the desert—lovely flowers—and the sea—and it is all in a fairly small space—many high thin waterfalls pouring down the mountains.

—Georgia O'Keeffe, in a letter to Russell Vernon Hunter, Oct.–Nov. 1939

Papaya Tree—ʻĪao Valley, 1939
Oil on canvas
19 x 16 in. (48.3 x 40.6 cm)
Honolulu Academy of Arts, Gift of the Georgia O'Keeffe Foundation, 1994 (7894.1)
© Honolulu Academy of Arts

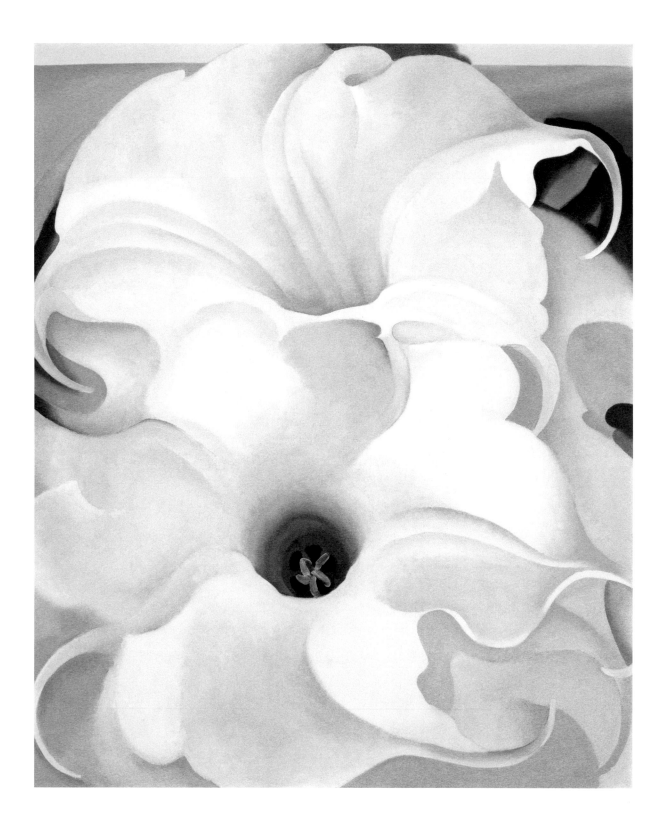

PREFACE

Maria Ausherman

I discovered Jennifer Saville's exhibition catalogue, *Georgia O'Keeffe: Paintings of Hawai'i,* at the Kaimukī Public Library in Honolulu. Reading it I was inspired to learn that a twelve-year-old girl, Patricia Jennings, had served as Georgia O'Keeffe's personal guide while O'Keeffe visited Maui in 1939. As a mother of two daughters, a teacher, and a graduate student in art history, I wanted to learn more about this encounter between the great painter and the young girl. I contacted Jennifer Saville, curator of the 1990 exhibition of O'Keeffe's Hawai'i paintings at the Honolulu Academy of Arts, and she graciously forwarded a letter to Patricia. I continue to feel honored that Patricia allowed me to help bring her story to light.

Patricia lived in Australia at the time, I lived in Hawai'i, and so we relied on letters to exchange information about her experiences. Whenever Patricia traveled to the Islands to visit her family, we always met for dinner to fine-tune the details of her time with O'Keeffe. Their days together had a pivotal impact on Patricia's life and, I believe, on O'Keeffe's art and spirit as well. I am grateful to Patricia for showing me the immense beauty of Georgia O'Keeffe's art and for becoming a dear friend in the process. I believe Georgia O'Keeffe did some of her best work in Hawai'i.

Less than three years after O'Keeffe's visit, Pearl Harbor was tragically attacked and the United States entered World War II. The world suddenly changed, and Patricia's memories of her time with Georgia O'Keeffe sustained her through this difficult period. As long as we keep our stories, our friendships, and our art, we will not lose the joy of being alive.

New York City
APRIL 2011

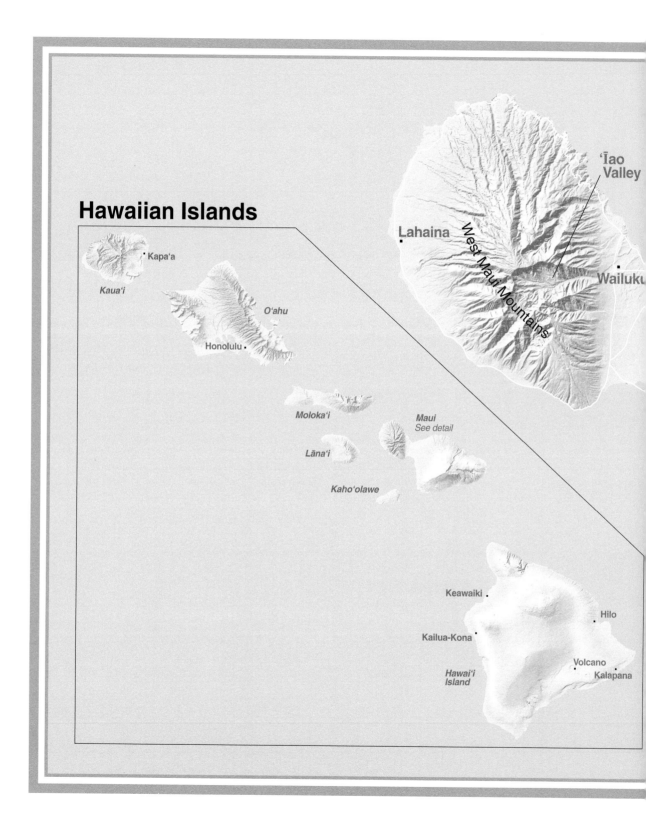

Hawaiian Islands

Kaua'i
- Kapa'a

O'ahu

Honolulu

Moloka'i

Lāna'i

Maui
See detail

Kaho'olawe

Lahaina

'Īao Valley

West Maui Mountains

Wailuku

Keawaiki

Hilo

Kailua-Kona

Volcano

Hawai'i Island

Kalapana

PLACES GEORGIA O'KEEFFE VISITED

Maui

Hāna Road

Central Maui

Wailua Village

Upper Nāhiku

Lower Nāhiku

Wai'ānapanapa

Honomā'ele

Kula

Hāna

'Aleamai

Leho'ula Beach

Haleakalā Summit

Hāmoa

Wailua Falls

'Ohe'o Gulch

Kaupō

Kīpahulu

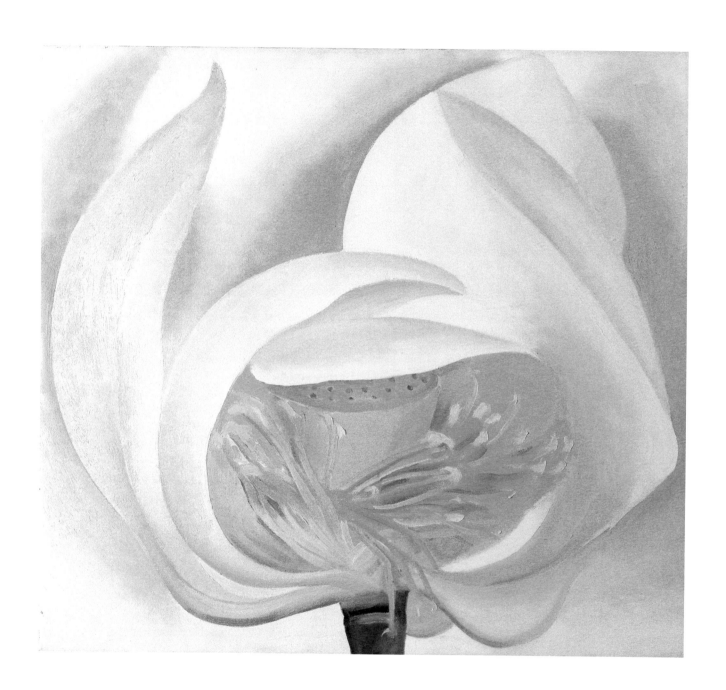

INTRODUCTION
Jennifer Saville

During her long career and following her death at the age of ninety-eight, Georgia O'Keeffe's life and work took on mythic proportions. Celebrated for the beauty and power of her painting, admired for her strength of character and fiercely unapologetic independence of spirit, O'Keeffe was deeply moved by nature and—drawing on the world around her—created an exceptional corpus of work ranging from abstraction to realism. Numerous retrospective exhibitions and biographies, and a museum dedicated to her work, have elucidated much about this extraordinary painter. Yet little has been published about her visit in 1939 to Hawai'i, which came at a critical time in her life and career and produced twenty remarkable paintings.

In the summer of 1938, N. W. Ayer & Son, at the time one of the nation's oldest and most successful advertising firms and since absorbed by a larger conglomerate, approached Georgia O'Keeffe with a proposal from the Hawaiian Pineapple Company (shortly thereafter renamed the Dole Company). The agency invited O'Keeffe to the Islands as its guest and, in exchange, requested two paintings of unspecified subject for use in a national advertising campaign. Breaking away from the company's previous emphasis on the nutritional and health benefits of pineapples in its marketing materials, in the late 1930s N. W. Ayer & Son began a campaign to capture the consumer's attention with the allure of Hawai'i. They used sketches and paintings of Hawaiian subjects by artists such as Yasuo Kuniyoshi, Millard Sheets, Isamu Noguchi, and Georgia O'Keeffe to promote Dole products.

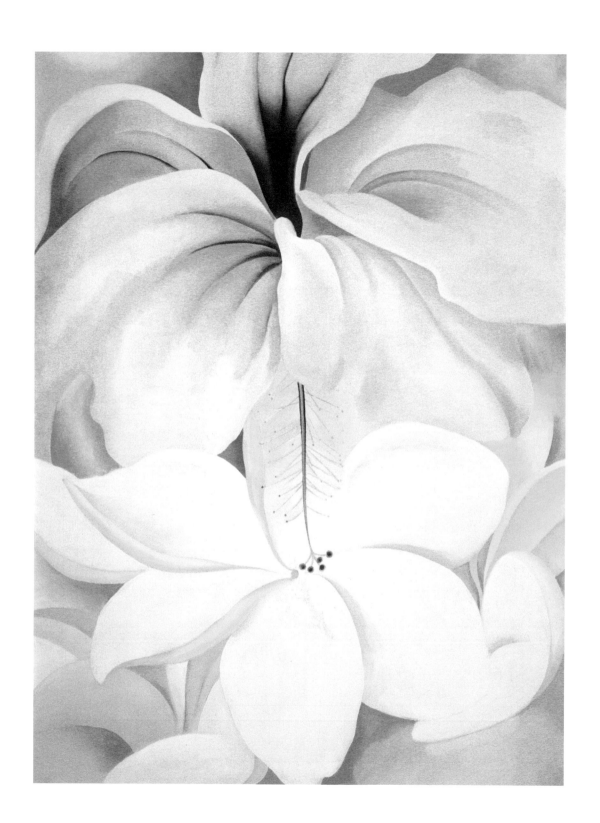

By the 1930s, corporate recognition of the selling appeal of fine art as a marketing tool led to an unprecedented level of cooperation between artists and advertisers. N. W. Ayer & Son, as much as any other ad agency, fostered this strategy, and Charles Coiner, an art director for the company, was instrumental in matching art to product. He selected upscale images for educated and sophisticated readers of "class," or coated-paper, magazines, believing that even if "they [were] not already familiar with the artist, [they suspected] they should be."

O'Keeffe was no stranger to commercial art as she drew lace and embroidery designs for a Chicago fashion house's advertisements in 1909 and received commissions, probably between 1918 and 1923, from Cheney Brothers, a large New York silk company. Finding success as an artist in her own right, however, she left such projects behind and adopted an elitist attitude toward the fine arts. In 1924, she told her sister Catherine, "A large proportion of the people who think they want to be Artists of one kind or another finally become commercial artists—and the work that they send out into the world is a prostitution of some really creative phase of Art."

In the following decade O'Keeffe reversed her position and accepted several commissions for commercial and public use. She took part in the interior mural painting at New York's Radio City Music Hall after the Mexican painter Diego Rivera was dismissed from the project, and she painted four jimsonweeds in bloom, her largest flower painting, for Elizabeth Arden Beauty Salon in Manhattan. The following year, Steuben Glass commissioned twenty-seven artists, including Henri Matisse, Isamu Noguchi, Fernand Léger, and O'Keeffe, to create designs for the decoration of glass forms. O'Keeffe submitted a jimsonweed blossom that was wheel-engraved on the bottom of crystal bowls.

Coiner recalled that O'Keeffe took some convincing before accepting his

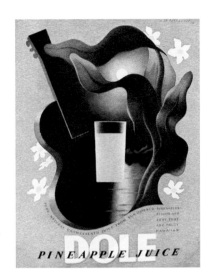

Ad by designer and artist A. M. Cassandre, 1938, for Dole Pineapple Juice

Hibiscus with Plumeria, 1939
Oil on canvas
40 x 30 in. (101.6 x 76.2 cm)
Private collection
Courtesy Gerald Peters Gallery
© Georgia O'Keeffe Museum

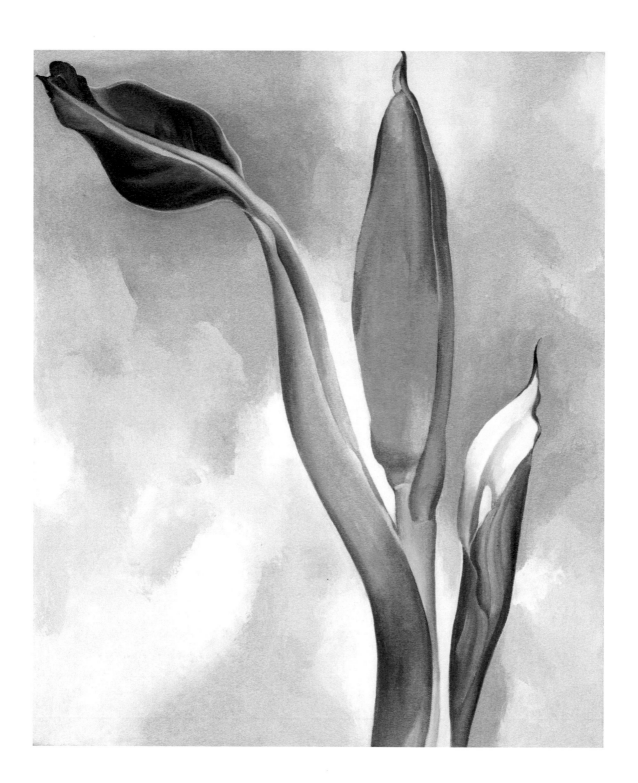

Pink Ornamental Banana, 1939
Oil on canvas
19 x 16 in. (48.3 x 40.6 cm)
Extended Loan, Private
Collection
© Georgia O'Keeffe Museum

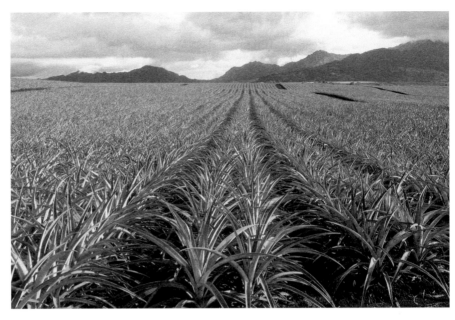

Pineapple fields, O'ahu

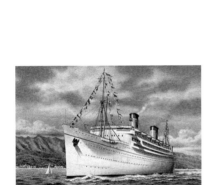

The *Lurline*

invitation to Hawai'i. Ultimately she decided to take advantage of Dole's offer, and on January 30, 1939, her husband, the photographer and gallerist Alfred Stieglitz, saw her off at New York's Grand Central Station. She arrived in Honolulu nine days later, sailing from San Francisco on the *Lurline*, a Matson Navigation Company ship. She spent nine weeks in Hawai'i, most of the first four on O'ahu. Local newspapers noted the arrival of this "famous painter of flowers" visiting the Islands at the invitation of Dole Company. The day after her arrival, the Atherton Richards family, prominent supporters of the arts, held an afternoon tea at their Honolulu home in her honor.

A week later, O'Keeffe saw the pineapple fields "all sharp and silvery stretching for miles off to the beautiful irregular mountains.... I was astonished—it was so beautiful." She told Ayer's representative in Honolulu that she wanted to live near the fields and paint the pineapples. Since only fieldworkers lived there, the company rejected her proposal, despite O'Keeffe's protests that she, too, was a worker and could live wherever she wished. Hoping to placate their guest, Dole presented her with what she described as a "manhandled" pineapple. "Disgusted with it," she did not paint the fruit while in the Islands.

On February 23, midway through her sojourn on O'ahu, O'Keeffe flew to Kaua'i

White Bird of Paradise, 1939
Oil on canvas
19 x 16 in. (48.3 x 40.6 cm)
Georgia O'Keeffe Museum
© Georgia O'Keeffe Museum

Postcard of pineapple field near
Honolulu

*Natural Stone Arch, Waiʻānapanapa
State Park, Hawaiʻi,* 1939
Georgia O'Keeffe
Photographic print
2 1/2 x 2 7/8 in.
Georgia O'Keeffe Museum
Gift of The Georgia O'Keeffe
Foundation (2006-06-1105)
© Georgia O'Keeffe Museum

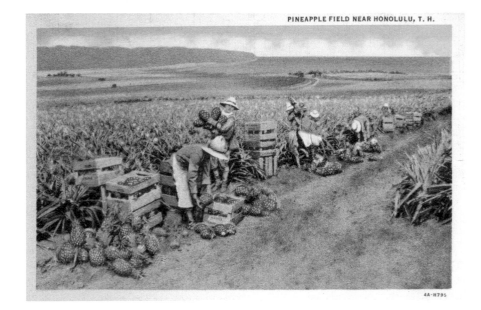

PINEAPPLE FIELD NEAR HONOLULU, T. H.

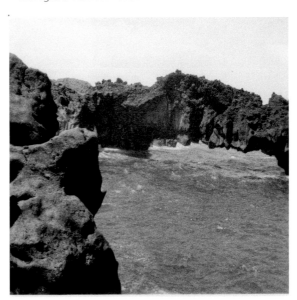

on one of the early interisland planes. Her brief, two-day visit to Hawaiʻi's north-ernmost inhabited island was filled with scenic drives, house calls, and a studio visit. One hostess took her to the Kapaʻa studio of the artist Reuben Tam. Flora Benton Rice, a leading supporter of the arts and grande dame of island society, escorted O'Keeffe to a friend's garden and entertained her for dinner. Robert Allerton and John Gregg hosted her at their estate, Lāwaʻi Kai, formerly the summer home of Queen Emma and now the National Tropical Botanical Garden. Later, O'Keeffe wrote to Allerton and Gregg: "It is over a year since I spent the day with you on your lovely island—I remember it all very vividly—… I hope that if you remembered me you knew that you had given me a lovely day—that I liked it—and that I appreciated it even if I did not write to tell you so."

On March 10, O'Keeffe flew from Honolulu to Maui and headed directly to Hāna, an isolated community on the north-eastern corner of the island. Robert Lee Eskridge, a painter who visited Hawaiʻi regularly, had arranged for her to stay at the home of Willis Jennings, manager of the Kaʻelekū Sugar Plantation in

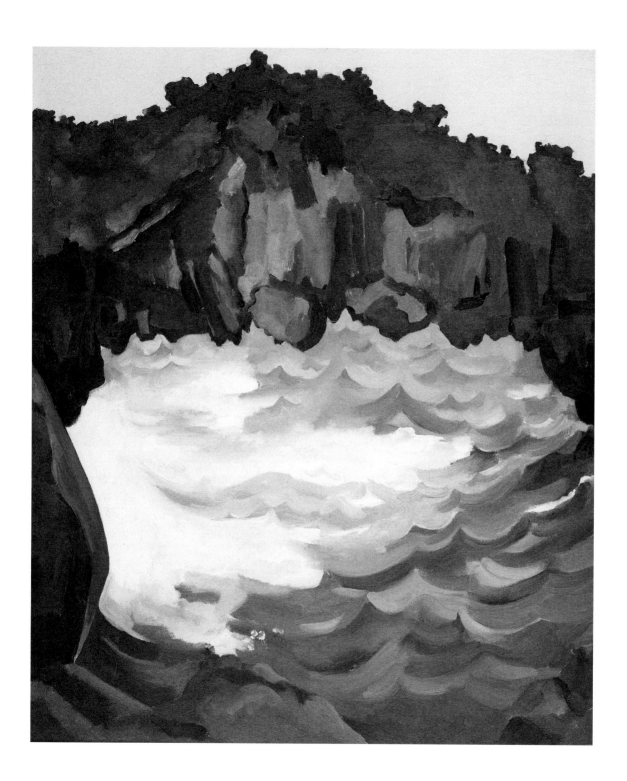

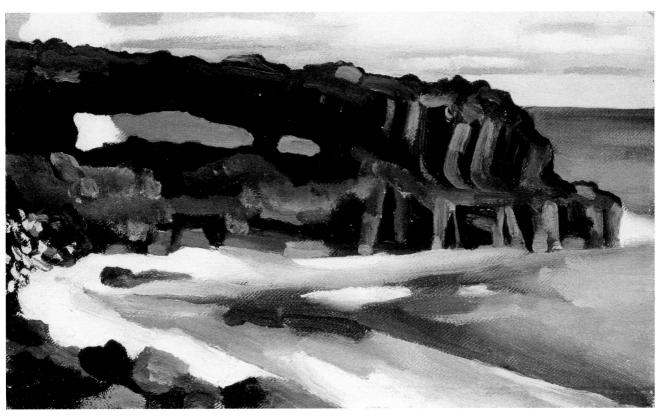

Above
Black Lava Bridge, Hāna Coast—No 2,
1939, Oil on canvas
6 x 10 in. (15.2 x 25.4 cm)
Honolulu Academy of Arts
Gift of the Georgia O'Keeffe
Foundation, 1994 (7893.1)
© Honolulu Academy of Arts

Facing
Black Lava Bridge, Hāna Coast, No. I,
1939
Oil on canvas
24 x 20 in. (61 x 50.8 cm)
Honolulu Academy of Arts
Gift of the Georgia O'Keeffe
Foundation, 1994 (7892.1)
© Honolulu Academy of Arts

Hāna, owned by C. Brewer & Co. Since Jennings's wife was in California and he was busy with plantation work, O'Keeffe was given the family's car to explore the area's tropical vegetation, sheer cliffs, spectacular waterfalls, and jagged lava flows, accompanied and guided by Jennings's twelve-year-old daughter, Patricia.

O'Keeffe and Patricia spent time at Waiʻānapanapa's lava-scarred coastline, visited the "Seven Pools" of ʻOheʻo Gulch (today part of Haleakalā National Park), hiked near Piʻilanihale Heiau (today part of Kahanu Garden, National Tropical Botanical Garden) and the abandoned rubber plantation in Nāhiku, admiring at each place the beauty of Hawaiʻi's dramatic landscapes and exotic blossoms. In a letter to her friend Ettie Stettheimer, O'Keeffe described the Hāna coast as "a place where all the shoreline is black lava—sometimes black sand." Noting that such a waterfront is "very handsome," she remarked that "the lava washes into such sharp and fantastic shapes." She also commented on the pervasive smell of

Left and above: Hāna Highway, Maui

the sugar mill in Hāna and remarked that she had tried raw fish and had worn the thonged sandals of grass and wood favored by the locals. "It hurt at first, but I get on very well now."

After ten days in Hāna, O'Keeffe returned to Wailuku, staying at the now long-gone Maui Grand Hotel. Willis Jennings drove her there along the narrow, winding coastal road that had been completed in 1927. She called on at least one local dignitary and drove to nearby ʻĪao Valley several times. It was there that young Patricia Jennings remembers having the opportunity to watch O'Keeffe paint the waterfall at the end of the valley. O'Keeffe's pleasure in visiting ʻĪao Valley is apparent in her description to Ettie Stettheimer:

> Ten minutes up back of [Wailuku] is a wonderfully beautiful green valley—
> sheer green mountains rising as straight up as mountains can—waterfalls
> when it rains—lots of them and it rains often but the rain doesn't feel wet
> as it does in N.Y. The valley road is so narrow and twisting that driving 10
> miles an hour is fast enough—and 20 is dangerous speeding. I… drive up

It is sixty miles in the country—up the coast— …hard to describe because it varies so— … sometimes grass—sometimes cane— sometimes bamboo— … very steep high cliff like hillsides covered with small ferns— … there are many water falls— masses of rank trees and bushes—all new to me—It was a nice drive—up and down hill—around bends— always the sea with usually its black rim of lava at the edge—

—Georgia O'Keeffe, in a letter to Alfred Stieglitz, March 13, 1939

the valley with a feeling of real fear and uncertainty because of the winding road—…The road not only winds—it is often just a narrow shelf on the side of the mountain—in many places too narrow to pass another car.

ʻĪao Valley, Maui

When I first came to Maui I wrote you about the beautiful green valley—Well—it is a wonderful valley—I've been painting up it for three days and it is just too beautiful with its sheer green hills and waterfalls

—Georgia O'Keeffe, in a letter to Alfreid Stieglitz, March 23, 1939

Page 14
Waterfall, No. I, ʻĪao Valley, Maui, 1939
Oil on canvas
19 1/8 x 16 in. (48.6 x 40.6 cm)
Memphis Brooks Museum of Art,
Memphis, Tennessee
Gift of *Art Today* (76.7)
© Georgia O'Keeffe Museum

Page 15
Waterfall, No. 2, ʻĪao Valley, 1939
Oil on canvas
24 x 20 in. (60.1 x 50.8 cm)
Private collection
© Georgia O'Keeffe Museum.

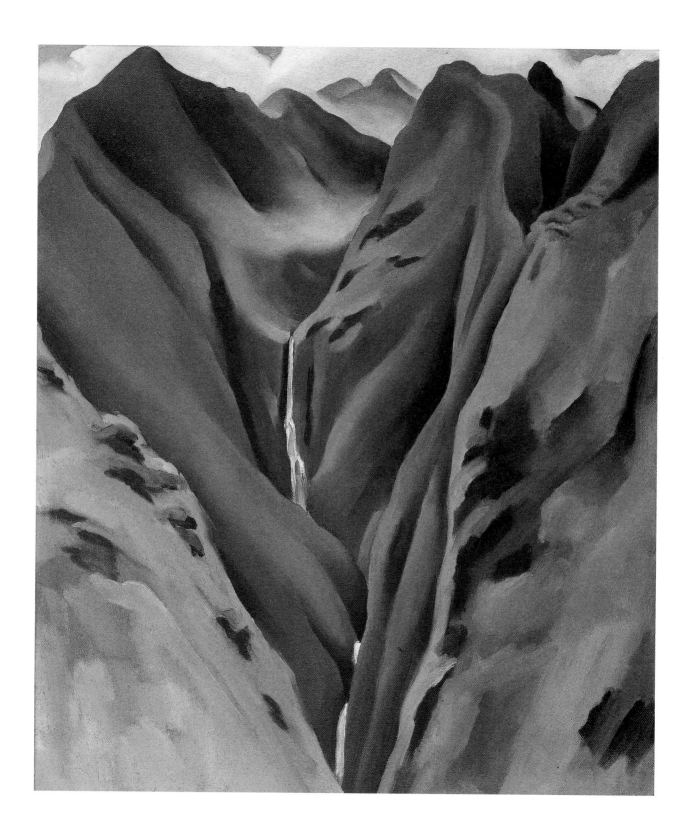

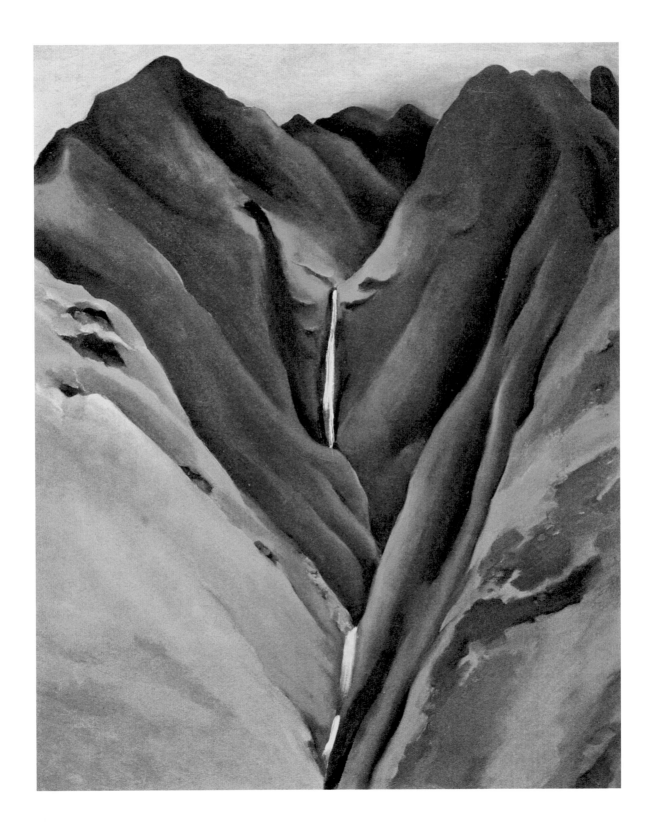

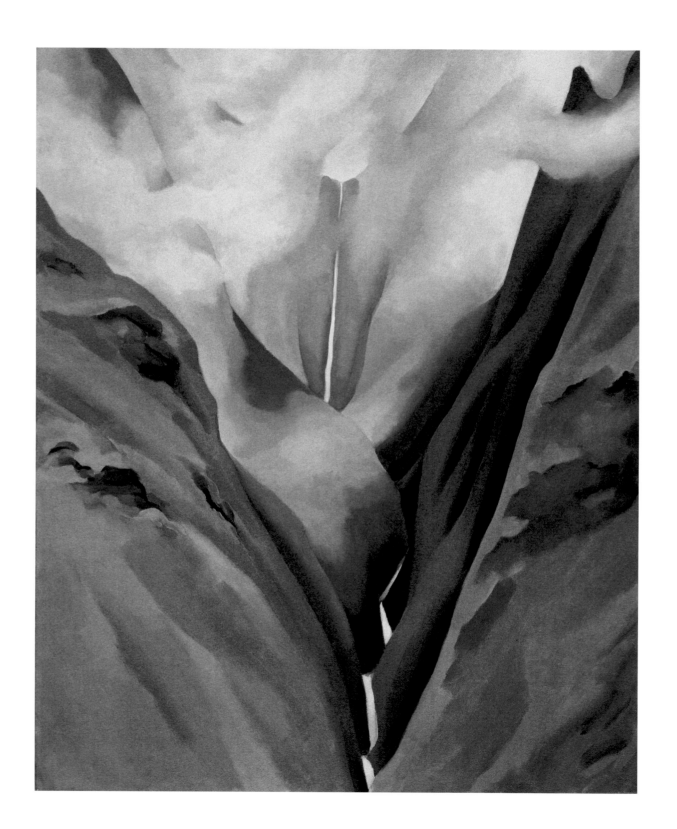

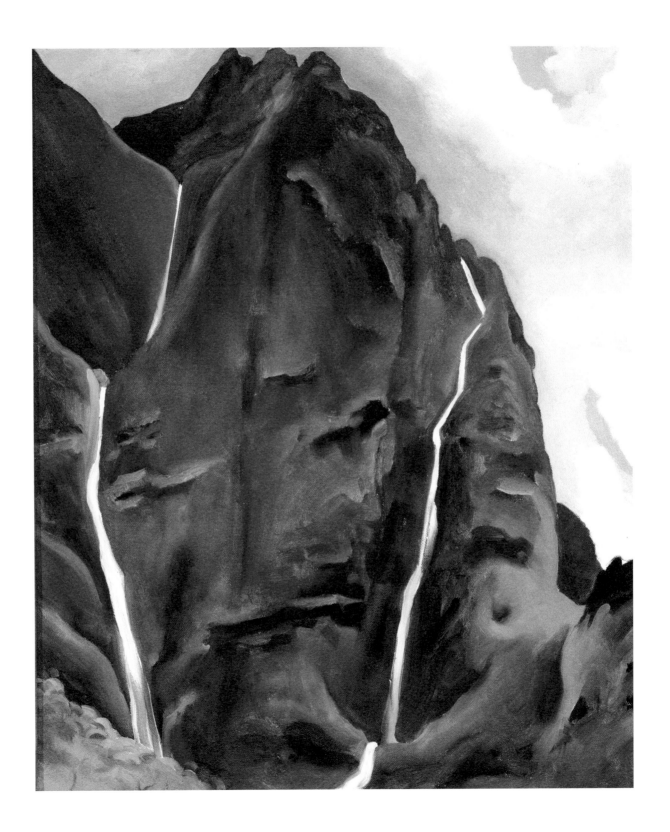

Kalapana black-sand beach
Kalapana, Hawai'i, 1925
Photograph by Ray J. Baker
Courtesy of Bishop Museum

Georgia O'Keeffe's time in Hāna and 'Īao Valley was pleasing and productive. Reflecting on her time on Maui, she wrote, "I enjoy this drifting off into space on an island—… I like being here and [I'm having] a very good time.… I'd as soon stay right here for a couple of months but I seem to have to move on."

On March 28, 1939, O'Keeffe boarded the overnight interisland steamboat *Waialeale* for Hilo on the eastern shore of Hawai'i Island. Arriving the following morning, she was greeted by Irma and Leicester Bryan, the territorial forester and a good friend of Willis Jennings. Escorted by Mrs. Bryan and by Caroline and Margaret Shipman, of a prominent Hilo family, O'Keeffe spent the day at the black-sand beach at Kalapana, now buried under lava and still the site of volcanic activity.

The interisland steamboat *Waialeale*

They continued on to Kīlauea, a volcano, where O'Keeffe stayed on the crater rim in the Volcano House hotel. Unsettled by the open vents and fissures and signs of ground movement, O'Keeffe wrote, "I didn't care for that place. I don't like steam coming out of the earth and holes in the road where the earth has opened up and not closed properly."

Jules Tavernier
(1844–1889)
Wailuku Falls, Hilo
Pastel on paper
23 1/2 x 35 in.
(59.7 x 88.9 cm)
Honolulu Academy
of Arts. Gift of
Anna Rice Cooke,
1934 (12555)

Page 16
Waterfall, No. III, ʻĪao Valley, 1939
Oil on canvas
24 x 20 in. (60.1 x 50.8 cm)
Honolulu Academy of Arts, Gift of
Susan Crawford Tracy, 1996 (8562.1)
© Georgia O'Keeffe Museum

Page 17
Waterfall End of Road ʻĪao Valley,
1939
Oil on canvas
19 x 16 in. (48.3 x 40.6 cm)
Honolulu Academy of Arts,
Purchase, Allerton, Prisanlee and
General Acquisition Funds and with
a gift from the *Honolulu Advertiser,*
1989 (5808.1)
© Georgia O'Keeffe Museum

She left the following day for the west side of the Big Island of Hawaiʻi, where she was a guest at the Kona Inn in Kailua. At this small hotel, O'Keeffe met Richard Pritzlaff, breeder of Arabian horses, chow dogs, and peacocks. Pritzlaff also had a home outside of Abiquiu, New Mexico, the town that had drawn O'Keeffe to the American Southwest since 1929. With him as her guide, O'Keeffe visited the sites of the Big Island, met local ranchers, and admired the ornamental blossoms in their gardens. Writing about the Island of Hawaiʻi in a tone of appreciation, if not awe, she commented that she saw "fourteen or fifteen thousand foot mountains—[and] bare lava land more wicked than the desert—."

On April 10, 1939, Georgia O'Keeffe returned to Honolulu and then left the Hawaiian Islands on April 14 on the *Matsonia.* After brief stopovers in Los Angeles and San Francisco, she continued on to New York by train.

In a letter of May 3, 1939, to the painter Arthur Dove, Alfred Stieglitz noted, "Georgia is back & hard at work.—" Her period of industry proved short,

however, as O'Keeffe was weakened by stomach problems, headaches, and weight loss. Although she had been busy painting in Hawai'i, her obligation to present the Dole Company with two canvases remained unfulfilled. Finally, she found the strength to paint, and in late June or early July submitted depictions of a papaya tree and the spiky blossom of a lobster's claw heliconia.

N. W. Ayer & Sons had not stipulated a pineapple plant, but they had clearly hoped she would paint one. Disappointed in receiving a papaya tree instead of a pineapple, Coiner spoke with O'Keeffe and, despite her arguments that she would not have accepted the commission under any terms other than absolute liberty of choice, obtained her consent to have a pineapple flown from Hawai'i. Thirty-six hours later, one appeared at her doorstep, somewhat the worse for wear. O'Keeffe begrudgingly conceded the attractions of the pineapple: "It's a beautiful plant.... It is made up of long green blades and the pineapples grow on top of it. I never knew that."

On July 11, Stieglitz noted, "Georgia did manage to finish the ad painting and it was shipped (they were shipped, 2—) to Calif. to-day. I hope the advertising pages look well." Indeed, the paintings *Pineapple Bud* and *Crab's Claw Ginger, Hawai'i* appeared in magazines nationwide, including *Vogue* and the *Saturday Evening Post*, accompanied by a brief but evocative statement such as: "Hospitable Hawaii cannot send you its abundance of flowers or its sunshine. But it sends you something reminiscent of both—golden, fragrant Dole Pineapple Juice."

O'Keeffe regained her strength over the summer of 1939 and resumed painting in October. It is unclear which Hawaiian subject paintings she completed while in the Islands and which ones she worked on in New York "from drawings or memories or things brought home." In any case, on February 1, 1940, her annual exhibition at Stieglitz's gallery, An American Place, opened. It included twenty canvases depicting Hawai'i's flowers, landscapes, and fishhooks. The response to

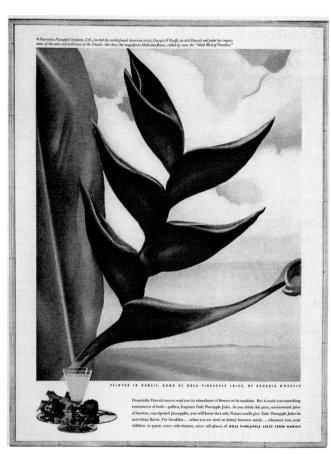

Ad for Dole Pineapple Juice, 1940

Heliconia, 1939
Oil on canvas
19 x 16 in. (48.3 x 40.6 cm)
Private Collection
© Georgia O'Keeffe Museum

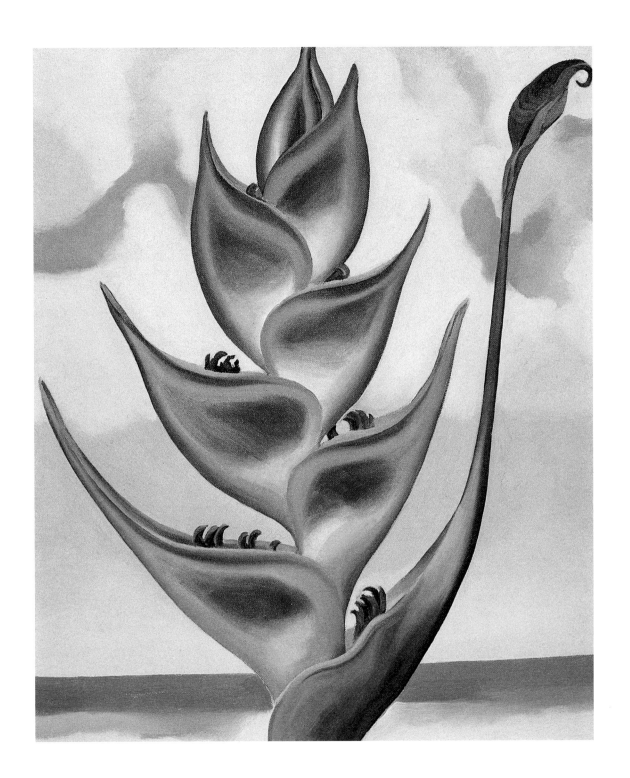

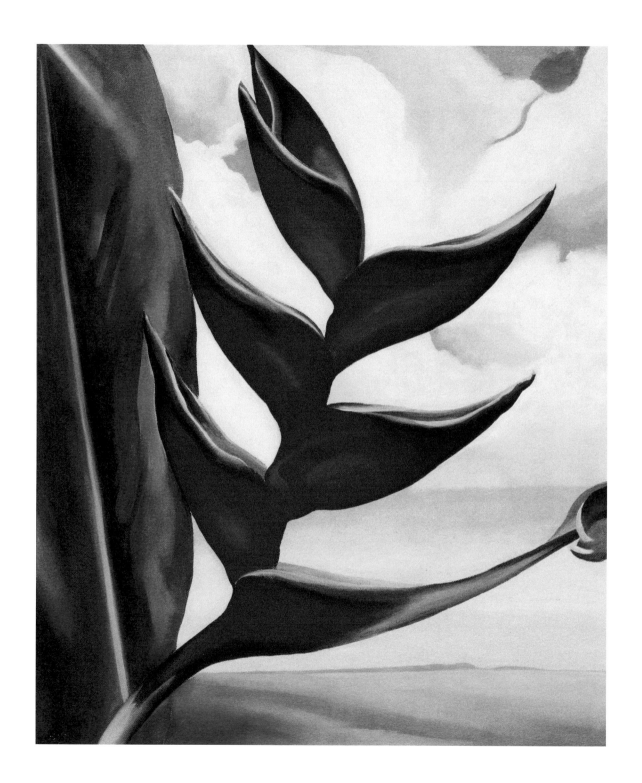

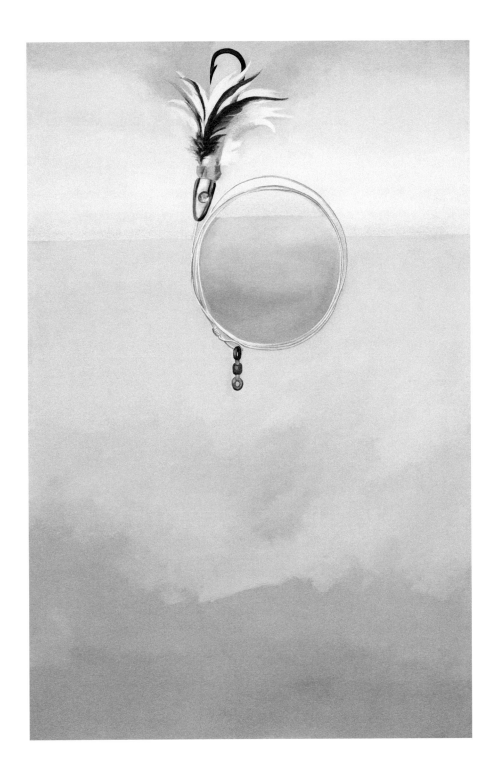

Crab's Claw Ginger,
Hawai'i, 1939
Oil on canvas
19 x 16 in.
(48.3 x 40.6 cm)
Collection of Sharon and
Thurston Twigg-Smith,
Honolulu
© Georgia O'Keeffe
Museum

Fishhook from Hawai'i,
No. 2, 1939
Oil on canvas
36 x 24 inches
(91.4 x 61 cm)
Museum of Fine Arts,
Boston, Alfred Stieglitz
Collection, Bequest
of Georgia O'Keeffe
(1987.540)
© Museum of Fine Arts,
Boston

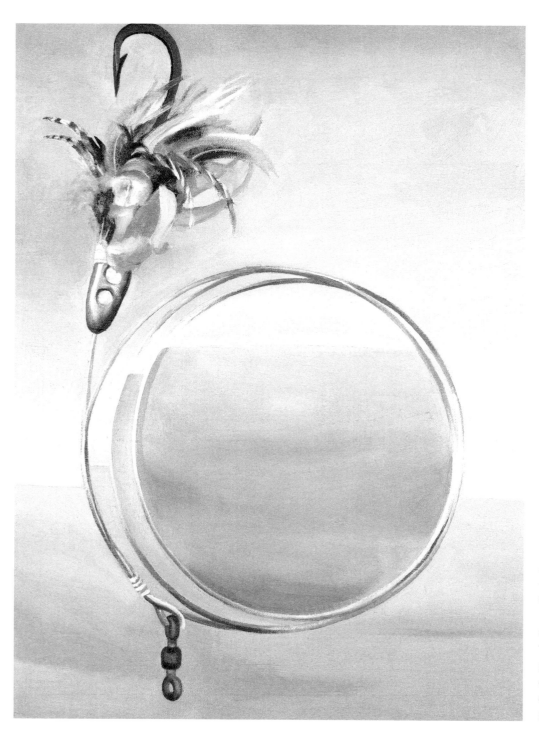

*Fishhook from Hawai'i
—No. I*, 1939
Oil on canvas
18 x 14 in.
(45.7 x 35.6 cm)
The Brooklyn Museum
(87.136.2), Bequest of
Georgia O'Keeffe
© The Brooklyn
Museum, New York

these Hawai'i paintings was enthusiastic, with critics commenting on each theme represented. The *New York World-Telegram* remarked, "Her pictures, always brilliant and exciting, admit us to a world that is alien and strange.... Her bird of paradise, her hibiscuses and her fishhooks silhouetted against the blue Hawaiian water are exciting and beautiful." Henry McBride, O'Keeffe's friend and a critic for the *New York Sun*, noted, "the landscapes, flower pieces and marines in this collection all testify to Miss O'Keeffe's ability to make herself at home anywhere."

Stieglitz informed Eliot Porter, a friend, photographer, and exhibitor at An American Place, that "her exhibition is on the walls and creating quite a stir. The irony of it all is that everybody feels that her work is better and healthier." To the painter Arthur Dove, Stieglitz commented that the gallery had been a "madhouse" and that the exhibition received "much appreciation. Great adulation." He summarized the exhibition for another painter and friend, William Einstein, stating, "Many believe it to be a health-giving one to all coming to the place."

Despite her illness, O'Keeffe expressed her delight with Hawai'i and contradicted the popular belief that her trip catalyzed her infirmity: "It wasn't the islands that did it to me either—.... The islands just staved off my having to get into bed before." To her friend Russell Vernon Hunter, she wrote, "I had a wonderful time out on the islands and loved it—Yes I worked—it is beautiful for painting as they have everything.... I flew from one island to another—several beautiful trips—Yes, I liked it."

Periodically O'Keeffe commented to friends that she looked forward to visiting Hawai'i again. She wrote to the photographer Ansel Adams, "I have always intended to return [to Hawai'i].... I often think of that trip at Yosemite [with you] as one of the best things I have done—but Hawaii was another." It is believed she fulfilled this wish in the 1950s with a visit to Willis and Marie Jennings, Patricia's parents, in Honolulu, and most certainly in 1982, when she returned to Hāna, Maui, but did not paint.

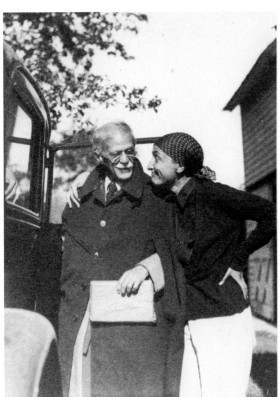

Alfred Stieglitz and Georgia O'Keeffe, Lake George, New York Yale Collection of American Literature, Beinecke Rare Book and Manuscript Library, Yale University

Pineapple Bud, 1939
Oil on canvas
19 x 16 in. (48.3 x 40.6 cm)
Collection of Mr. and Mrs.
Jon B. Lovelace
© Georgia O'Keeffe Museum

O'Keeffe never commented specifically on her Island subject matter, although in her autobiography she noted her regret at never returning to pick up a piece of red coral that she had once seen on a Hawai'i beach. Instead, she seems to have been overwhelmed by the lush beauty of the land and the flowers she saw, the fantastic configuration lava flows assume, and the infinite sense of space reaching to the ocean's horizon. Her Hawai'i paintings represent an attempt to come to grips with the beauty and spirit of a group of islands geographically and culturally distant from the landscapes and lifestyles to which she was accustomed. Her willingness to meet new pictorial challenges brought her to Hawai'i and her skills as an artist allowed her to realize, as she once commented to an interviewer, her ultimate wish: "Filling a space in a beautiful way. That is what art means to me."

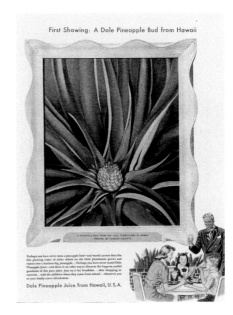

Ad for Dole Pineapple Juice, 1940

Jennifer Saville's introduction is adapted from her book Georgia O'Keeffe: Paintings of Hawai'i *(Honolulu Academy of Arts, 1990), the catalogue of the last full exhibition of O'Keeffe's Hawai'i paintings, which she curated. We are grateful to the Honolulu Academy of Arts for permission to excerpt from their publication.*

Georgia O'Keeffe with
Pineapple Bud, 1940

A very nice young man from Ayres [sic]…had two of the long flower necklaces in his hand—white ones—that he put over my head…—Mrs. Richards was on the dock—a string of beautiful red coral like flowers and some one else a pink one—then more white ones till I was more dressed up than I've ever been—…they are wonderful things—the flowers strung together like wonderfully wrought metal work—only all colors.

Georgia O'Keeffe, in a letter to to Alfred Stieglitz, February 8, 1939

Georgia O'Keeffe on her arrival in Honolulu, 1939
Photograph by *Honolulu Advertiser*

COMING INTO BLOOM

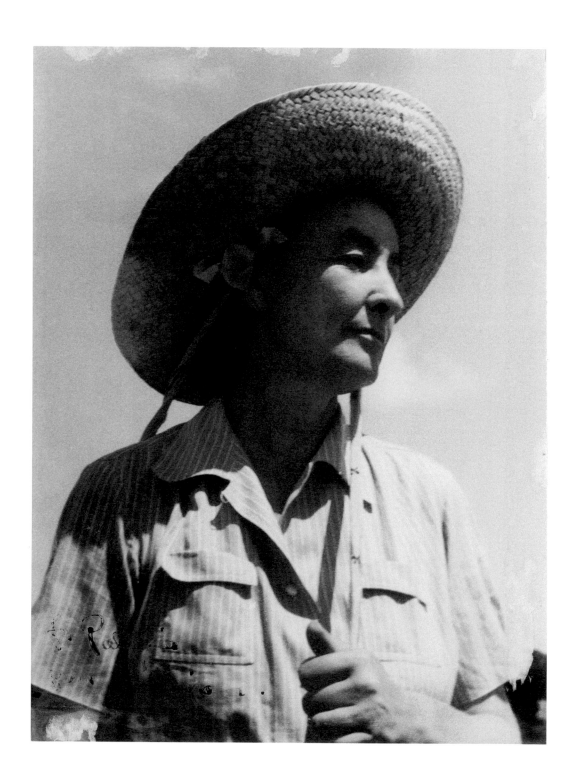

COMING INTO BLOOM
My Maui Adventures with Georgia O'Keeffe

Patricia Jennings and Maria Ausherman

She Can Be Difficult

The child … is so lovely—a flower in full bloom with the sun on it.

—Georgia O'Keeffe in a letter to Alfred Stieglitz, March 20, 1939

Georgia O'Keeffe in Hāna, 1939
Inscribed *For Patricia, from Georgia*
Photograph by Harold Stein
Courtesy of Patricia Jennings

I vividly remember the ten days I spent with Georgia O'Keeffe in isolated Hāna, Maui. My father, Willis Jennings, was manager of Kaʻelekū Sugar Plantation there, and we hosted Miss O'Keeffe at our home and then drove with her to Central Maui. At the impressionable age of twelve, and totally awestruck, I was able to serve as her personal guide.

I was home schooled by my mother, Marie Jennings, and each day after our morning lessons, I was expected to amuse myself. I had few friends my own age, so I spent hours with my beloved rust-and-white English spaniel, Lucky Star of Cranmore, as well as reading the many magazines we subscribed to and the best-seller books Mother liked to keep around.

On a clear day in October 1938, Mother and I were sitting on our glassed-in *lānai*, working on fractions and percentages, which I despised, and the feeling between us was tense.

"You're not listening!" Mother scolded.

I sighed. Would our math lesson ever end?

Suddenly, Lucky dashed across the living room floor to greet my father, who had arrived home for lunch. Dad strode in with his usual air of confidence, gave Lucky a pat on the head, placed several rolled-up magazines and the Sunday papers on the coffee table, and handed Mother a stack of letters.

Leafing through the envelopes, Mother observed one from Robert Eskridge. "How nice. I'll take it to read over lunch."

"Oh," I piped in. "Is Bob coming for a visit?" The artist Robert Lee Eskridge was one of my favorite family friends.

"Hush," Mother said, reading the letter, "Bob says that Georgia O'Keeffe will be coming to Hāna and staying with us. Willis, you must have known! When did you plan to let me know?"

"Oh, a day or two ahead," Dad responded, winking at me. Seeing Mother's annoyance, he added, "I received a letter a few weeks ago. The Dole Company has commissioned Miss O'Keeffe to do some paintings in Hawai'i, and Bob insists she should stay here. I wrote and said it would be fine. Hell's bells, it isn't for months! And you won't have to do a thing except show her around. The maids will do the rest."

Mother was not amused. She hated being teased about the maids running the house.

The Jennings home in Hāna, Maui, c. 1939
Known today as the Plantation House, it is part of Travaasa Hotel Hāna (formerly Hotel Hāna-Maui)
Courtesy of Patricia Jennings

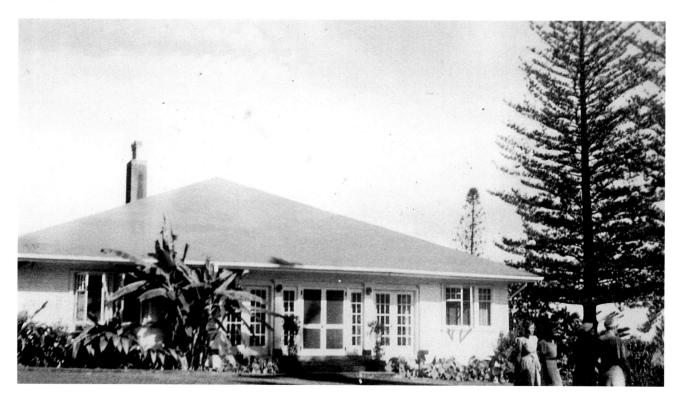

Willis and Marie Jennings, 1940
Photo courtesy of Patricia Jennings

Georgia O'Keeffe coming to Hāna! I'd read about her—a stern-looking woman married to a very famous photographer who took pictures of her naked. My mind raced.

Mother picked up the letter again. "Bob says she has a reputation for being difficult, but he's certain she'll be charmed by us." She appeared to be warming up to the idea of a visit by Georgia O'Keeffe, perhaps even relishing the thought of telling her friends.

A Change of Plans

On a rainy day in late December, I lay on my bed gazing at the pale blue wallpaper sample Mother had brought home from Honolulu. With its dainty pink flowers, it would be perfect for my dollhouse.

"Pat, I need to talk to you," Mother burst in. "I've just received a cable from California. Your grandmother is very ill, and I need to leave in the morning to be with her."

"Oh, no! What about Georgia O'Keeffe?" I asked.

"You and your father will do just fine. I'm sorry I'll have to miss her visit, but I must be away. She can drive my car, and you can show her around."

I was terrified. "Bob said she can be difficult! For months you've been telling everyone how difficult she is."

"Patricia, there are times one has to face things and make the best of them."

Easy for her to say.

The Artist Arrives

Two months later, on the morning of March 10, 1939, Harold Stein, the director of Maui County's Boy Scouts and a close family friend, phoned from Wailuku to say that he and Georgia O'Keeffe were leaving the Maui Grand Hotel and would be arriving that afternoon. The road to Hāna, lush with foliage and waterfalls, was more than fifty miles long, with hundreds of hairpin turns. Roadwork often caused delays, especially when a cliffside was being dynamited.

At noon, moments after Dad came home for lunch, we heard the crunch of gravel on the driveway. "That can't be Harold already," he said, looking out the window. "Oh, hell's bells! It's the plantation auditors. I completely forgot they were coming. Pat, can you tell Isami we'll have two more for lunch and that they'll be here for two or three days? I'll head them over to the Big Cottage."

I raced to the kitchen and Isami, accustomed to my father's forgetfulness, took the news in stride. "Lunch ready half hour—go tell Sato, Isami like one head lettuce and some ripe tomato quick."

Harold Stein, Boy Scout meeting, Honolulu, 1940
Photo courtesy of Bishop Museum

Patricia with Lucky, 1939
Photograph by Harold Stein
Courtesy of Patricia Jennings

She handed me a basket, and I ran to the vegetable garden. "Sato-san, Isami quick need one head lettuce and ripe tomatoes." He pulled up a head of leaf lettuce and laid three bright red tomatoes beside it in the basket. I ran back to the house.

"Now remember," Dad said before going back to his office, "I want you to be here when Miss O'Keeffe arrives. Take her to the Little Cottage yourself. Don't leave it to Harold or the maids. And tell Harold to use the small bedroom in the Big Cottage."

My heart pounded as I went to my room to wait. I began flipping through the pages of my dog-eared copy of *Heidi*. I knew it almost by heart but was much too nervous to start anything new. Within the hour, Lucky perked up his ears—a car was approaching. We looked out the window and there they were! Lucky led me to the back door, and we stepped out to greet them.

Tall, lanky Harold Stein had the appearance of a blond, unbearded Abe Lincoln. He smiled broadly, then hurried round the car to open the door for Georgia O'Keeffe. The first thing I saw was her dark hair pulled tightly in a bun. Then I noticed her sunken eyes, her long narrow nose, and the deep creases between her eyebrows. Her skin looked nearly brown, and even her blouse and skirt were tan and brown. Her face was expressionless, and she didn't say a word.

"Georgia, this is Patricia, Willis Jennings' charming daughter," Harold said, bending over to scratch Lucky's floppy ears. "And this wiggly creature is Lucky, an important member of the family." Harold glanced at me reassuringly.

"How do you do, Miss O'Keeffe?" I said, mustering my courage. Thankfully, Mother had warned me not to call her Mrs. Stieglitz, which apparently she didn't like. "My father is at work. I'll show you to your room."

"I've explained to Miss O'Keeffe about your mother being away," Harold said, as he opened the trunk of his car. He turned to Georgia, who looked utterly spent. "You'll be in good hands here. The best hospitality on the island."

Harold lifted the artist's four tapestry bags, and before I could reach the two smaller ones, Georgia had picked them up herself. As we walked to the cottages, I found the silence unbearable, so I began chatting chirpily, and pointing to each fruit tree we passed. "This is a mango. That's lychee. Over there are tamarind, star fruit, and avocado. Would you like a star-fruit, Miss O'Keeffe?" She took no notice.

"Perhaps later," Harold responded.

When we arrived at the Little Cottage, I opened the door and held it for them. "This is where Robert Eskridge always stays. He says he likes it because there's plenty of room for his painting things and lots of light. The dressing room and bath are in the back."

Georgia scanned the large square room. Atop a small table was a tray holding a thermos of ice water, a glass, and two tangerines.

"This is very nice," she said, almost under her breath. Grateful to hear anything, I smiled, and could see that she wanted to be alone.

"I'll go catch a wink," Harold said. "See you at cocktail time."

I was almost back at the house when I remembered I hadn't offered them tea. I ran back, but the cottage door was already shut. Oh dear, I thought, I've made a mistake already!

Robert Lee Eskridge (1891-1975)
Red Torch Ginger
Watercolor
16 1/2 x 16 1/2 in. (41.9 x 41.9 cm)
Collection of Monica Jennings

Robert Lee Eskridge
Inscribed *To Willis and Marie, with best aloha, Bob Eskridge*
Photograph by Murle Ogden
Courtesy of Patricia Jennings

Plantation-Style Dinner

Our Japanese maid, Teruko, served cocktails in the living room. Georgia O'Keeffe and Harold Stein sat together, across from Mr. Smith and Mr. Turner, the likeable accountants who came twice a year to review the plantation's books. My father was in his favorite chair, and I sat near him, with Lucky at my feet.

When we'd moved into the plantation manager's house three years earlier, the living room was desperately gloomy. My father, who had a flair for remodeling, had two side walls removed and opened the living room to the enclosed *lānai*, giving it a spacious, airy feel. Mother insisted on installing a fireplace, and we did enjoy a warm fire on Hāna's cool, wet days. Above the fireplace was a mantle-to-ceiling mirror that reflected the garden. Robert Eskridge's painting of a red torch ginger hung to the left of the mirror, and his portrait of me at age eleven was on the right.

"How was your stay on O'ahu?" Dad asked Miss O'Keeffe.

"Not at all what I expected," she replied.

"What happened?" Mr. Smith, the accountant, inquired, reaching for a handful of macadamia nuts.

"I'd hoped to stay near those lovely, silvery pineapple fields, the ones that stretch for what seem like miles up to the mountains. At one point, I got out of the car to see the plants more closely and was immediately warned not to get close, as they were sharp and dangerous. I asked if I could stay at the workers' village and was told that would be disrespectful and embarrassing. Then, when I got to the hotel, a pineapple was delivered to my room—with its head cut off and the center all cut in spears! I was furious and sent it back."

"Not a good start," Harold observed, shaking his head.

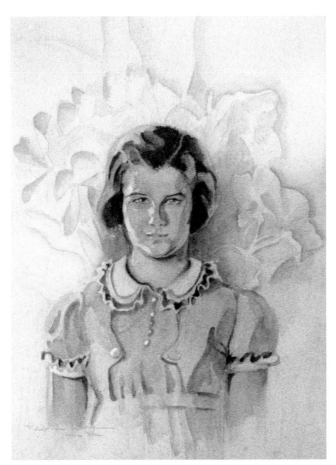

Robert Lee Eskridge (1891-1975)
Portrait of Patricia, 11
Watercolor
13 1/2 x 18 1/2 in. (34.3 x 47 cm)
Collection of Patricia Jennings

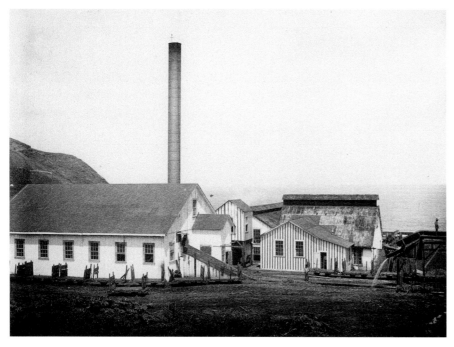

Hāna Sugar Mill, c. 1904
Photo Courtesy of Bishop Museum

"I did enjoy meeting other artists, and I saw fascinating plants, but no other pineapples." Her hands on her glass were slim and lovely, and I watched her with utter fascination.

"Well, we must see that your Maui experience is more enjoyable," Dad proposed.

Just then, Teruko entered the room and whispered in my ear. I nodded and waited for a chance to speak.

"So far, it's been lovely," Georgia replied. "There's so much to see. Today's drive was beautiful, although, I must admit, exhausting. Cascades of vegetation and one waterfall after another—so different from the desert, yet no less spectacular. I hope you'll be joining me on some excursions."

My father's face tightened. "I'm afraid I won't be able to. I hope you won't mind driving yourself in our car. Patricia will go with you as your guide." The way he and Georgia looked at each other seemed strange to me.

Garnering my courage, I announced, "Dinner is served." Everyone walked into the dining room and, with renewed confidence, I said, "Miss O'Keeffe, please sit here, next to my father." He pulled out her chair. After directing the others to their seats, I sat across from Dad, in my mother's chair.

The candles were lit on either side of a low dish filled with spider lilies, and the goblets were filled with ice water. Each place had a bowl of clear, warm broth, with little orbs of avocado floating on top. Butterballs that Isami made from butter she'd churned that day were on the small plates. Teruko passed a tray of crackers, then left the room.

"What a charming girl!" Georgia said of Teruko. "Was it your wife's idea to have her wear traditional dress?"

"Oh, no," Dad clarified. "It's customary in Hawai'i for Japanese maids to wear kimono and a simple obi. Teruko is a pretty little thing, isn't she?"

The accountants nodded, remarking that they'd noticed Teruko's beauty on previous visits. Georgia shook her head, laughing. Everyone seemed to relax, and the conversation flowed.

I was struck once again by Georgia O'Keeffe's long, tapered hands, and, recalling the *Time* photograph taken by her husband, I felt my cheeks blush. In that photo she was naked, her hands crossed over her breasts.

When everyone had finished their soup and set down their spoons, I rang the small, silver bell that was near my place. Our laundress Masako, also wearing her kimono, came in with Teruko to remove the bowls and saucers. Then Teruko placed a stack of warmed dinner plates in front of Dad, along with a silver platter of roast pork and potatoes.

"I hope there aren't any vegetarians here," he said wryly, as he carved a serving of roast pork and placed a small red potato and a bit of crackling alongside it on a plate. Teruko served Georgia first. As the only other woman, I received the second plate, and then the men were served. As Teruko and Masako passed the other dishes to each guest, Dad identified them—chopped *lū'au* greens, green beans, and finally homemade taro biscuits. Georgia looked intently at each one as it was being served.

"Are the vegetables all from your garden?"

"The potatoes are from Kula, on the other side of the mountain," Dad replied. "They like a cooler climate. Everything else is from Hāna."

Now that she was rested, she seemed to be enjoying the company of others. "How has your weather been?" she asked.

"We had too much rain last spring. When cane gets watery, it doesn't produce as much sugar." Dad seemed eager to talk about the weather, and I wondered, if

Night before last we went through the sugar factory— … By the time I leave the islands I am going to know so much more about sugar than I do about pineapples that is funny—

—Georgia O'Keeffe, in letters to Alfred Stieglitz, March 15 and 18, 1939

it was because he was a farmer or because Georgia O'Keeffe was asking.

"So, sunny days are best?"

"Yes, the sun produces sugar. Today was perfect, but a prolonged dry spell would also be a problem. We need showers now and again."

"What's your prediction for this month?" Mr. Smith asked.

"Mostly clear days with evening showers," my dad replied confidently. Then smiling warmly at Georgia, he added, "Nice weather for visiting." My usually stone-faced father was quite handsome when he felt relaxed, and, on occasions like this, he could be extremely charming. Ladies always seemed to like him.

Georgia smiled back. "I wouldn't want my interests to supersede the welfare of your crops. I'd like to see typical Hāna weather, the kind that produces such beautiful gardens."

Dad chuckled, then winked at the auditors. "Hāna can be rainy. Last April, we had a nasty flash flood. We don't need anything like that again. "

Grownups sure act funny when they're talking about the weather, I thought.

Harold turned the conversation to painting, commenting on the Ashcan School and some of the successful painters of the era—Hopper, Bellows, and Henri. Mother had instilled in me a deep appreciation of art, and every week when *Time* Magazine arrived, I read all the art articles. So I piped in, "I like Grant Wood. His paintings always look so tidy."

"Really?" Georgia said. "And what do you think of my paintings?"

"I know you paint flowers and skulls in the desert," I answered, embarrassed, and then remembering a recent review in *Time*, added, "and that you have a wonderful brush technique."

Sugar Cane Fields and Clouds, Hawai'i, 1939
Georgia O'Keeffe
Photographic print
2 1/2 x 2 7/8 in.
Georgia O'Keeffe Museum
Gift of The Georgia O'Keeffe
Foundation (2006-06-1099)
© Georgia O'Keeffe Museum

The cane fields sort of get under my skin—sort of fascinate me—and every day I learn more about them— When you get snatches of the sea through the sharp softly waving leaves it is really lovely—

—Georgia O'Keeffe, in a letter to Alfred Stieglitz, March 20, 1939

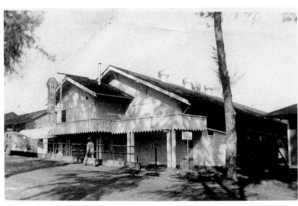

Hāna Theater, Hāna, Maui, c. 1940
Photograph by Toshimasa Hasegawa
Courtesy of Hasegawa family

She laughed uproariously. I didn't understand why, but I decided she was beginning to like me. Tearing my taro biscuit in half, I buttered its steaming purple center.

Georgia then recounted a story about her life in New York, and the four men at the table couldn't take their eyes off her. When she was interested in a subject, she glowed. Her eyes sparkled and her smile embraced you. Even without makeup, she looked beautiful!

"Are you planning to see *Gone with the Wind*?" I asked, having read the whole novel. "The magazines seem to write mostly about Vivien Leigh. There's a full-page picture of her in *Vogue*."

"Yes, I've seen it," Georgia replied. "It's funny to think of a British actress with a southern accent. Do you see movies often, Patricia?"

"The mailman drives a movie over with the mail three times a week. We see nearly all the films that come to Hāna."

"We could go to the theater tomorrow night," Dad suggested. "You might enjoy being with the plantation workers and their families. They're a wonderful mix of people."

I loved the idea of going to the movies with Georgia O'Keeffe. It wasn't a fancy theater, but we would see almost everyone from the village. I thought she would like that.

I glanced around and saw that everyone had finished eating, so I rang the little silver bell again. Georgia gave me a warm smile.

Teruko and Masako padded back into the dining room to clear the plates. Then they gave us each a dessert plate and spoon, a lace doily, and a fingerbowl of warm water with a fragrant *pikake* blossom floating on top. I dipped my fingers into the warm water, dried them on my linen napkin, and placed the doily and fingerbowl above my plate. When everyone had done the same, the maids served us each a stemmed crystal glass of ice cream.

"This is delicious!" Georgia remarked. "But I don't recognize the flavor."

"It's guava. Isami makes it," Dad said. "Guava trees are terrible pests on the plantation, but their fruit is excellent for jellies and ice cream."

"Dinner has been simply delightful," she said.

"Please Call Me Georgia"

After breakfast the next morning, Georgia packed her art supplies into the trunk of Mother's car. The two gardeners, hoes on their shoulders, walked toward the flowerbed, and the accountants headed through the garden to the plantation office. Harold drove off on Boy Scout business.

"I'm glad you'll be showing me around, Patricia. Willis, are you sure you don't mind her coming with me?"

"This will be fine. Patricia knows all the spots of interest as well as any of us." Dad opened the car door for Georgia, and Lucky jumped in.

"Get out at once!" she said sternly.

"Lucky always comes with us," I pleaded. "I'll sit in back with him. Please."

"No."

"Patricia," Dad said in his no-nonsense voice, "Lucky can stay home and pester the gardeners. Now, off you go. We'll see you at lunchtime."

I dragged Lucky out of car and began wondering if Georgia actually wanted me as her guide. The magic of last night's dinner vanished as Lucky walked to the steps and lay down, his head and ears drooped over his front legs.

Trying to recover from my disappointment, I asked, "Would you like to go to the ocean?"

Wai'ānapanapa black-sand beach, Hāna, Maui

"Yes, that will be fine."

"I can show you the way to Wai'ānapanapa."

"How do you say that?" she asked.

"Wai-ah-nah-pah-nah-pah. It means glistening water."

I pointed out Ka'elekū Camp as we drove by. "Your father tells me that practically everyone in Hāna works for the sugar plantation and they live in camps, organized by race."

"Yes, each group—Filipinos, Japanese, Okinawans, Chinese, Portuguese, and

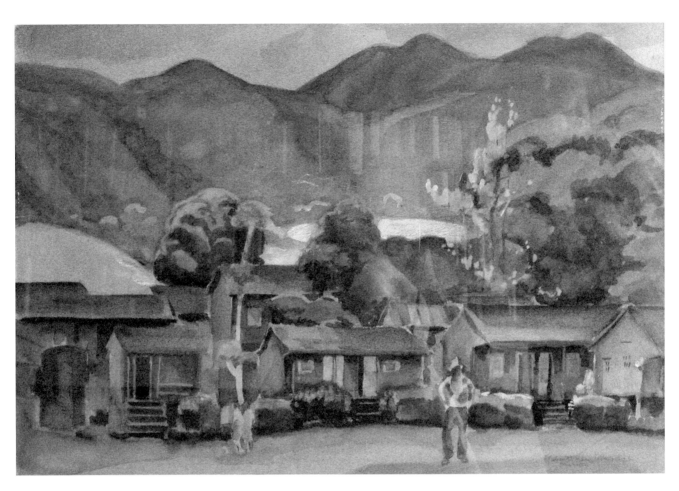

Robert Lee Eskridge (1891-1975)
Ka'elekū Camp
Watercolor
22 x 15 in. (55.9 x 38.1 cm)
Collection of Monica Jennings

Puerto Ricans— has a separate camp, except the Hawaiians. They own their own houses."

"The Japanese don't live with the Okinawans?" she asked.

"No, they don't like each other very much. A long time ago, the Japanese forced Okinawa to become a part of Japan."

"Does everyone else get along?"

"Mostly. But once in a while a Filipino man will get stabbed during a cock fight."

This didn't seem to startle her. In fact, she seemed more relaxed, so I asked, "Where are you from?"

She smiled. "My grandparents came from Ireland and Hungary. My brothers, sisters, and I were born on a farm in Wisconsin."

"So that's why you know so much about plants?"

"Yes, I suppose. I learned to love the outdoors while living on the farm. What about you, Patricia?" she asked. "Where are you and your parents from?"

"My mother is from California. She came to Hawai'i after college to teach school for a year. My father was born in Pennsylvania, and after high school he decided to go to Alaska. But his parents forced him to go to the College of William & Mary. He didn't stay there long, though. Instead, he went to the Midwest and got a job on a farm in South Dakota. After three years he'd saved enough to sail to Alaska, his dream. But the train he took to San Francisco was delayed, and by the time he got there, the ship to Alaska had already sailed. Another ship was heading to Honolulu, so he took that one instead. He got a job on a sugar plantation, and that's where he met mother. My sister—she's twenty—was born in Honolulu, and I was born on the Big Island. We moved to Hāna three years ago."

Georgia listened with keen interest. "So you really are an island girl."

I nodded proudly.

We pulled into the small parking area at Wai'ānapanapa, next to a fence with a hand-painted sign that read "*KAPU*." "What does that mean?" she asked.

'It's the Hawaiian pronunciation of taboo. It means Keep Out," I explained. Later I learned that *kapu* also means sacred or forbidden. "May I show you a cave? It's one of my favorite places."

I led Georgia to a steep trail that wound down through a dense grove of *hala* trees. "These trees' aerial roots make me think of witches on brooms," I said excitedly. "I feel like I'm entering an enchanted forest."

"Yes, a special Hawaiian one," she embellished.

Pink and white impatiens surrounded the shadowed cave entrance, and Georgia peered into the cavern that was filled with crystal-clear water. "Sometimes we swim in here. If you dive under the ledge, you come to another cavern," I told her.

"The back wall has reddish streaks," she said.

"There's a legend about that. A beautiful princess, the daughter of an important *ali'i*, chief, fell in love with a commoner, a fisherman. Her father wouldn't allow them to marry. He had arranged for her to marry a chief, a man she despised. So the princess and her maid ran away and hid in this cave. Every night her lover brought them food, and they stayed here for quite a while.

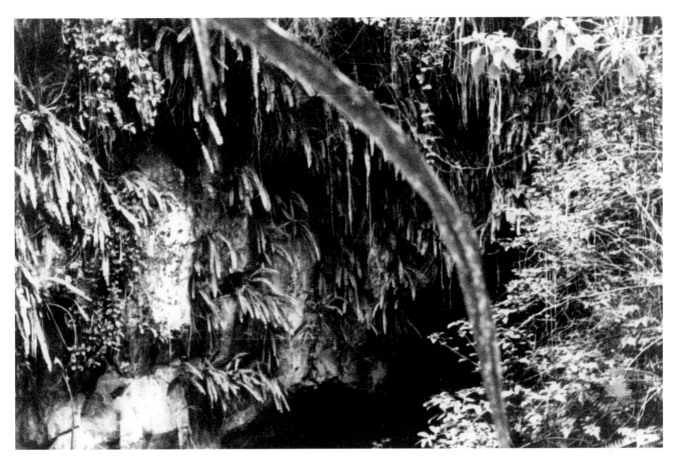

Cave at Wai'ānapanapa, c. 1939
Photo courtesy of Bishop Museum

"Then one day, a warrior of her father was looking into the cave's waters and saw the reflection of the princess sitting on a ledge being fanned by her maid. He told the chief, who immediately ran to the cave. In his rage, the *ali'i* grabbed hold of his daughter and her maid and smashed them both to death against the cave wall. Those red streaks are their blood."

Georgia listened intently, then reached into the pool and picked up a shiny black stone. "It's quite beautiful," she said, gazing at the stone.

"Let me show you some others." I replied. I waded into the water and reached up to a ledge high above my head. "Goody, they're still here!" I grasped a small tin box and opened it. Inside were three polished stones like the one Georgia had just found.

"They're called Pele's tears," I said. "Pele is the volcano goddess. She gets mad if

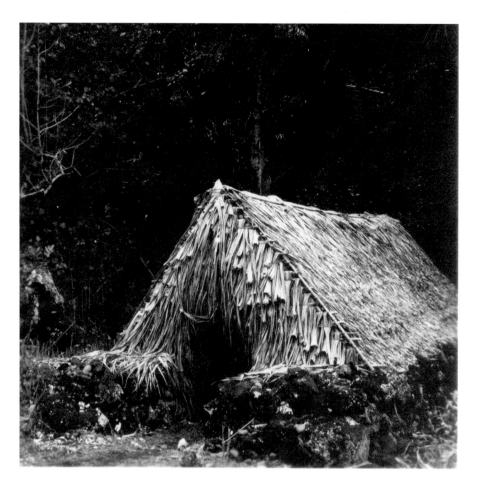

you take her stones away. All stones belong to Pele and must stay where they are found. If you take them away, she'll put a curse on you."

"They're beautiful," Georgia said, handing me the stone she'd found. "Add this to your collection, for luck."

"Whenever I open the box after you leave, I'll remember you, Miss O'Keeffe," I said shyly.

"I'll remember you, too, Patricia. Please call me Georgia."

Beyond the cave was a small, black-sand beach, and on the beach was a *lauhala*-thatched canoe shed, where Hawaiian fishermen stored their canoes and fishnets. "I watched Bob Eskridge paint a picture of that shed," I boasted, "and it won a watercolor award in Chicago."

Robert Lee Eskridge (1891-1975)
Waiʻānapanapa Canoe Shed
Watercolor
27 1/2 x 20 in. (69.9 x 50.8 cm)
Collection of Patricia Jennings

"That's very nice," Georgia said, "but I don't like to be watched while I paint. Can you amuse yourself somewhere?"

"Oh, okay, sure," I replied, disappointed once again. "I'll walk along the cliff. If the tide is high enough, the blowhole will be shooting water up in the air."

"Fine," she said. "Off you go."

Georgia set up her easel on the cliff's edge facing a jagged sea arch not far offshore, while I walked to where I could watch the blowhole. Below, the ocean was pounding against the black lava rock and formed a twenty-foot spray of

Street scene, Hāna, Maui, 1945
First store on left is Hasegawa General Store. Smoke stack in background is the sugar mill.
Photograph by Toshimasa Hasegawa
Courtesy of Bishop Museum

water through the blowhole. I could feel the salty mist on my face. I wondered if Georgia, some distance away, was feeling the spray too.

Half an hour later, Georgia called out, pointing to her head. "I must have a hat!" She packed up her painting supplies, and we headed into town. The plantation store didn't have a hat that suited her, so we drove to Hasegawa General Store. There she found a wide-brimmed, straw hat.

"This is perfect. But how shall I keep it on in the wind?"

"I'll fix it," I assured her, assuming the confident air of my father.

When we returned to the house, Georgia went to the Little Cottage to work, while I dug through Mother's ragbag. I found a long strip of blue silk with white polka dots that had been trimmed from the hem of one of my sister's dresses. I placed the silk band around the crown of Georgia's hat and carefully separated the straw weave just enough to push the two silk ends through the brim. Now she would be able to tie the ends under her chin.

As I ran to the Little Cottage, Harold drove up, ready for lunch. "Look," I shouted, "Georgia has a new hat!" She stepped out of the cottage and laughed heartily as she put it on.

I am sending you three bad snaps that Harold Stein took of me at Hana—That string on my hat is a knotted rag Patricia gave me to tie it on with—

—Georgia O'Keeffe, in a letter to Alfred Stieglitz, March 31, 1939.

Georgia O'Keeffe on Leho'ula Beach, near 'Aleamai, Hāna, Maui, 1939
Photograph by Harold Stein
Yale Collection of American Literature, Beinecke Rare Book and Manuscript Library, Yale University

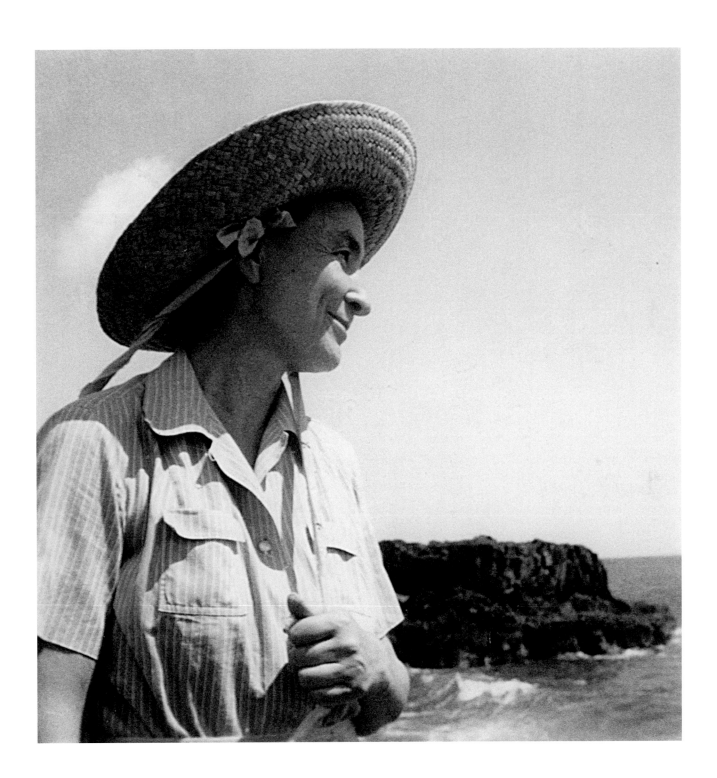

"Will you let me take a photograph of you wearing the hat?" Harold asked.

She agreed, and after he had taken several shots of her, she reached over and tied the hat on my head. "Take one of Patricia for me," she said.

Harold stood me in front of the eucalyptus tree, and I smiled proudly into his lens. "Beautiful," he declared.

Georgia laughed, "Now how about one with Lucky?"

Lucky was running about, acting like it was all a game. I returned the hat to Georgia, scooped up Lucky, and sat on the cottage's side steps, cuddling him as if he were a squirming baby.

"You're a good mom," Harold said.

I looked at Georgia, who was laughing behind Harold, and I realized how she made me feel special. She listened to everything I said as though each word was really important.

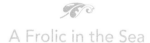

A Frolic in the Sea

The next morning at breakfast, while squeezing a wedge of lime over his papaya, Dad proposed to all our guests, "Shall we all go to Hāmoa after work for a swim? It looks like another fine day."

"I need to go to Kaupō and Kīpahulu," Harold said, "but I should be back in time." Winking at me, he added, "I'll bring Lucky in my car."

In the afternoon, Georgia and the accountants rode with Dad, while Lucky and I went with Harold to Hāmoa Beach. We parked on the hill overlooking the bay's tan-and-white-sand beach, and Harold, his gangly limbs flying, ran down the steep path, trailed by Lucky and me. For this special occasion, I wore my favorite red, green, and yellow-striped bathing suit. Harold, Lucky, and I plunged into the water, followed closely by Mr. Smith and Mr. Turner.

Dad took Georgia's hand and helped her down the path. She was wearing a blue-and-white striped short-sleeved blouse, army-green workpants, and the straw sandals Mother had left for her in the cottage. Dad spread a beach towel on the sand for Georgia, and then he joined us in the water. Why isn't she wearing a

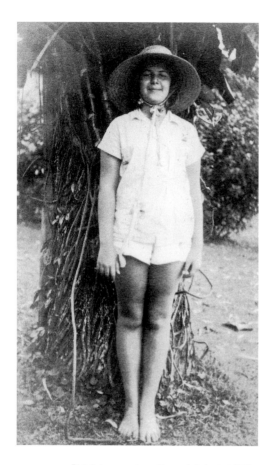

Patricia wearing Georgia's hat, 1939
Photograph by Harold Stein
Courtesy of Patricia Jennings

*Then in the late afternoon
went to the good sandy beach
and all went in the water—
dog and all—the air and sun
and water all just the right
temperature—And such
lovely trees and bushes—all
big leaved right at the edge
of the sand—rocks rising
up behind the trees—green
covered rocks —A beach
about three long blocks long
but quite perfect*

—Georgia O'Keeffe, in a letter to Alfred
Stieglitz, March 20, 1939

Hāmoa Beach, Hāna, Maui

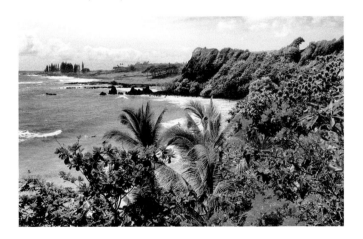

bathing suit? I wondered. Is she afraid of the water? Or maybe, like Mother, she doesn't want to get her hair wet.

Harold, Lucky, and I rode a few waves, and Georgia laughed as Lucky tumbled in the surf, always following me back in for more. After a short swim, Dad joined Georgia back on the beach, where they sat and chatted.

After what seemed like only a few minutes, Dad stood up and shouted, "Pat, it's time to head home." I swam back to shore and Lucky loped out of the water. Before anyone could stop him, Lucky shook himself vigorously, spraying saltwater in all directions, mostly on Georgia. She wiped her face and looked down at the blotches of water on the front of her shirt and pants.

"Love Patricia, love her dog," Dad said, shaking his head while he handed her a towel.

Back at the house, Georgia studied the portrait Robert Lee Eskridge had painted of me. "What are those flowers behind you?" she asked.

"They're white ginger. They grow in our backyard, but none are blooming now." I pointed to the tall flower arrangement in the Ali Baba vase near the arch to the dining room. "Those are red torch ginger and pink shell ginger. Every week Sato cuts the big stalks and Teruko arranges them. The ones that grow here are especially large and never stop flowering."

Georgia turned back to the painting. "Bob is well known here, isn't he?"

"Oh, yes. And he's wonderful! He stays in the Little Cottage two or three months sometimes, paints lots of pictures, then has a show in Honolulu to make money to travel. He wrote a book called *Manga Reva,* which was chosen by the Literary Guild, and another one called *Umi.* His whole name is Robert Lee Eskridge. He is from a well-known Virginia family, but they aren't rich anymore. Still, he visits England often and sees his cousin Lady Nancy Astor at Cliveden. When he comes back, he tells wonderful stories about people like Anthony Eden and the Churchills."

"Why don't you drive to Kīpahulu tomorrow?" Dad suggested, startling us as he came up from behind. "There might be some white ginger in bloom."

✍

Angel's Trumpet

The following day, Georgia and I headed down the coast to Kīpahulu. "I'm sorry Harold has to leave this morning," she said, glancing over at me from the steering wheel. I was beaming.

"Why are you so happy?" she asked.

"Harold says he'll be back on Friday and he'll bring Alexa and Aunt Dora with him. You'll like the von Tempskys. They live on a ranch in Kula, and their house is my favorite place in the world! It's English-style and, at four-thousand feet, it's always cool up there. When the mist blows, the moss on the shingles is so tall it shivers. And they have a gorgeous view of the West Maui Mountains. Alexa raises English spaniels. That's where Lucky was born."

"What else does Alexa do?"

"She paints, mostly portraits of local people. Mother says it's a shame that so much of her work is unfinished. Her studio is stacked with half-completed paintings."

"Is Harold Alexa's beau?"

"Beau?"

"Her boyfriend."

I was startled. I'd never thought about that. They both seemed so old—probably in their forties! "I don't think so," I said. "They're just friends." I loved spending time with Georgia. She was interested in everything and talked to me as though I were a grownup.

As we drove past an elderly Chinese man with a wispy beard, Georgia asked, "Who is that marvelous fellow?"

"He always walks here," I told her. "Alexa painted his portrait from a photo that Harold took."

Georgia nodded thoughtfully.

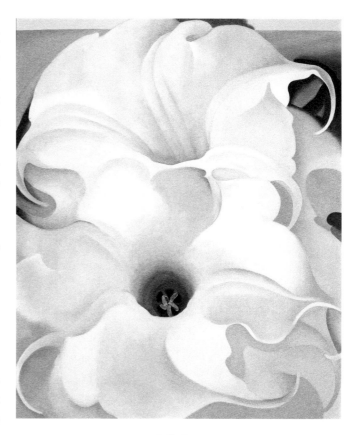

Bella Donna, 1939
Oil on canvas
36 1/4 x 30 1/8 (92.1 x 76.5)
Georgia O'Keeffe Museum
Extended Loan, Private Collection
(1997.03.03L)
© Georgia O'Keeffe Museum

Farther down the road, she spotted a shrub covered with white, horn-shaped blossoms. "What is that flower?" she asked, pulling over.

"Belladonna," I said, giving the local name for Datura, or angel's trumpet.

"It looks like jimsonweed, my favorite flower. They're all over the Southwest and grow to the size of a small tree. The blossoms are similar; they droop down instead of looking at you. On the way back, would you pick one for me?"

"Sure," I said gladly. "Georgia, why do you paint flowers?"

"Because they're beautiful. What others see in my work is up to them."

That afternoon Georgia O'Keeffe painted the angel's trumpet in the Little Cottage. She called it Belladonna, as I had told her. I wondered why she insisted on painting alone. I so wanted to watch her—the way I was able to with Bob and Alexa.

Slippery Slope

The next morning we headed out toward Kīpahulu again. This time we stopped at Wailua Falls, where the waters plunge straight down a sharp cliff surrounded by lush foliage in many shades of green. Georgia got out her easel and paints, and I walked along the edge of the gulch to look for some white ginger blossoms. There were none along the road, so I clutched the smooth-barked guava trees and slowly made my way down to the valley floor. There I was in an enchanted forest replete with flowerless ginger and a gurgling stream. Huge, mossy boulders were overlooked by a vast canopy of *kukui* trees. I imagined menehune— the two-foot-tall, industrious people who lived in Hawai'i before the Polynesians arrived—stepping out from behind one of the *kukui* trees. I could have stayed there for hours, exploring, but I sensed it was getting late, so I headed back up the hill. But it was slippery, and I kept losing my footing in the mud. Dad had taught me to grab onto the strong, well-rooted guava trees, and I managed to struggle on. When I got up to the top, I was completely out of breath.

"Don't you ever go off like that again!" Georgia shouted the moment she saw me.

"I was in the gulch looking for white ginger blossoms," I told her, fighting back the tears.

"I've been frantic for half an hour. From now on, you must stay in sight! Do you understand?"

I nodded, staring at the ground. She packed her painting equipment in the trunk of Mother's car, and we drove home in silence. At lunch, she said nothing.

"Why isn't she speaking?" Dad asked as soon as Georgia left the table.

"I wanted to find some white ginger for her, so I went off searching. She's always so busy painting; I didn't think she'd even notice."

"Where were you?"

"Wailua Gulch.'"

"You went into Wailua Gulch alone? Hell's bells, it's straight down! I'd never let you do that by yourself. No wonder she was upset. When are you going to learn to think before doing such a stupid thing?"

I felt devastated and ran to my bedroom. There, I dropped to the floor beside Lucky and bawled into his silky ears. Why did I always do the wrong thing when I wanted most to please?

Turbulent Sea

The sun was shining as Mr. Smith and Mr. Turner headed back to Wailuku along the Hāna Road. Georgia and I followed them as far as Lower Nāhiku, where, with a little toot, we headed down the steep road to the sea.

"Aren't the tiny churches here cute? Bob Eskridge did a painting of the Catholic church, but the coral-block Congregational one is my favorite." Georgia drove right by without saying a word. She's still mad at me, I thought.

When we reached the cliff at the bottom of the road, I tried once again to make conversation, while the winter sea churned beneath us. "They grew rubber not far from here in the early 1900s. You can see the remnants of the old concrete dock. When the ocean was calm, small boats took the rubber out to an anchored ship."

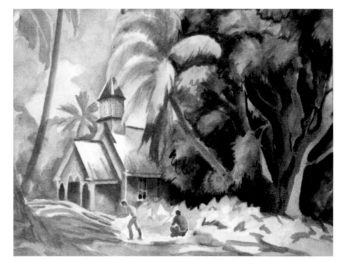

Robert Lee Eskridge (1891-1975)
Lower Nāhiku Church
Watercolor
23 x 17 in. (58.4 x 43.2 cm)
Collection of Patricia Jennings

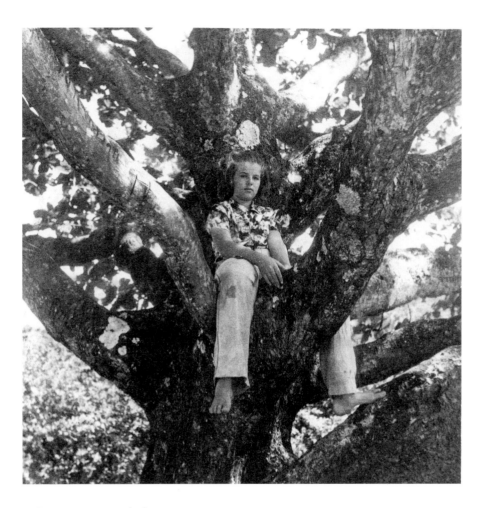

Patricia Jennings in a *kamani* tree
Photograph by Harold Stein
Courtesy of Patricia Jennings

Georgia remained silent.

"There's a little waterfall splashing into the sea a short way from here," I persisted. "Would you like to see it?"

"No."

She got her painting things from the car and placed them on the ground. Then, standing behind me, holding my right shoulder firmly, she said, "Now, where will you be?"

"Right here in this *kamani* tree. I've climbed it lots of times. Please don't worry; I'll be safe."

Georgia set up her easel a short distance away, while I settled comfortably on a

broad branch, my back resting against the trunk. This native Hawaiian tree was a wonderful spot for pretending to be atop a sailing ship, its prow plunging through the waves. As the turbulent ocean fifty feet below pummeled the lava rocks, the *kamani* trembled, reinforcing my sense of being aboard a ship at sea.

That night, Georgia came to the house for dinner scowling, and Lucky wiggled up to greet her.

"Get that beast out of my sight! He tramped right over my paintings when they were drying on the floor!"

Dad was appalled. "Patricia, take that dog outside at once!"

"You shouldn't have put them on the floor!" I said, bursting into tears and throwing my arms around my beloved Lucky Star of Cranmore. I fully expected to be sent to my room without dinner, but I knew that Lucky hadn't meant any harm, and I also knew he wouldn't have been in the Little Cottage if Georgia had latched the screen door.

After a long pause, Georgia began to laugh. She pulled me to my feet, gave me a big hug, and said, "You're quite right. I shouldn't have put them on the floor."

Dad looked relieved; he hated punishing me. Everyone began to relax, and we had a wonderful evening together. At bedtime, Dad gave me a big hug and a warm, "See you in the morning."

That night, as I lay across my bed, elbows on the windowsill, I looked out at the bright silvery moon, thinking how beautifully it shone on our yard. I heard voices and saw the dark figures of Dad and Georgia strolling hand-in-hand through the garden.

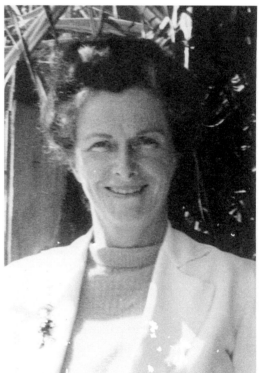

Alexa von Tempsky Zabriskie
Photo courtesy of Patricia Jennings

A Wonderful Day

At lunch the next day, Dad and Georgia looked rested and content. "Harold is bringing some company today," he said, "and I think you'll enjoy them.

"Dora von Tempsky is a special woman," he continued. "She was widowed when her daughter Alexa was only four and her son Robert just two. She took charge of the family ranch, ran it successfully, and, at the same

time, remained a charming lady. They're a talented family. Alexa paints portraits and raises dogs, and her cousin Armine von Tempsky has had some success as a writer."

"We have a copy of her book *Hula*," I added. "The story takes place here in Hāna, in the old house that stood right here before this one was built."

"Pat, would you find *Hula* for us?" Dad asked.

I skipped into the den, found the book, and handed it to Georgia. While she was leafing through the pages, Lucky's ears perked up.

Harold had arrived with Aunt Dora, Alexa, and Jed, Lucky's father. Lucky greeted them enthusiastically, barking loudly and wagging his tail madly. But his father, Jed the Genial Lad of Ware, had the dignity of a blueblood champion and ignored his ill-mannered son. Jed was so well known that, when he passed away in 1950 at the age of sixteen, there was an article on the front page of the *Maui News* titled, "Greatest Show Dog in TH [Territory of Hawaii] Dies."

'Ohe'o Gulch bridge and lower falls

That evening, Harold and Alexa sat together on the living room love seat. Alexa looked stunning in her stylish black dress. When Georgia entered the room, Harold rose, and she took his place beside Alexa. I noticed the crease between Georgia's eyes deepen at the sight of Jed and Lucky curled up in front of the unlit fireplace. She murmured something to Alexa, and Alexa smiled.

At dinner, Harold began the conversation. "Georgia, you, Alexa, and Bob Eskridge all studied at the Art Institute of Chicago. During the war, poor Bob got called into the army and spent a year and a half painting camouflage on tanks and trucks. Not much respect for artistic talent."

"I don't think my gift is special," Georgia responded. "It's determination and a lot of very hard work. It's sad that so many with talent don't have the willpower to work at it."

There was a sudden hush. Did she mean Alexa? I shouldn't have told her what Mother said. Was she being intentionally mean?

Dad deftly changed the subject. "Let's go to Hāmoa tomorrow for a swim."

"Isn't the water rough this time of year?" Aunt Dora asked. "And the trail down might be difficult for me. I suppose you could park the car at the old mill ruins on the point, and I could keep Jed with me and watch you from there."

"Dad, why don't we go to the Seven Pools instead?" I broke in. "It's an easy walk

from the bridge to the first pool, and there's plenty of grass for Aunt Dora to sit on." I turned to Aunt Dora and Alexa, "It's a good spot for a picnic, and, Alexa, you won't have to wash Jed if he goes in fresh water."

"An excellent idea," Aunt Dora said, and Alexa agreed.

The next morning, we set out for the Seven Pools of ʻOheʻo Gulch with our picnic hamper and several straw mats. Georgia insisted that Aunt Dora ride in front with Dad. Harold drove his car with Alexa beside him, and I sat in back between the dogs. When we got to the tiny bridge spanning ʻOheʻo Gulch, both cars parked.

"The pools are perfect for swimming today," I told Georgia. "We rarely see tourists here except for a few in the summer."

Waterfall on the Hāna coast, Maui

Dad added, "When it rains hard, there can be flash floods, and people have drowned."

Georgia looked up and down the stream. "It looks like there are more than seven pools," she observed. And she was right.

We walked down the hill from the bridge. At the first pool, water splashed in from the pool above it, the noise competing with roar of the ocean carrying rocks and pebbles onto the embankment. The waters formed a placid pool thirty yards in diameter and well protected from the churning ocean. Looking across the ʻAlenuihāhā Channel, we could see the snow-capped peak of Mauna Kea silhouetted above the clouds. Dad helped Aunt Dora find a comfortable spot to sit and propped a pillow against the picnic hamper for her back. Georgia took a short walk above the ocean, then settled down beside Aunt Dora. They chatted while the rest of us swam. Harold and I, followed by Lucky, climbed onto some boulders above the pool.

"No diving from up there," Dad shouted to us from below. "Jumping only. The water's deep, but there might be a hidden rock." Harold jumped first, clutching his

arms around his knees, and then I did the same. Lucky, not to be outdone, barked loudly until he had everyone's attention. Then he, too, leaped off the cliff, his long ears flying as he completed a doggie swan dive. Unimpressed, his father Jed swam quietly across the pool with Dad and Alexa.

We had a leisurely picnic, then drove back home. Georgia said she had work to do, and Aunt Dora wanted a rest.

"Pat, give me twenty minutes to shower and change, and then I'll beat you at cribbage," Harold challenged.

"Wonderful!" I said.

"Alexa, why don't we take them on and play four-handed?" Dad asked.

"Fine," she replied.

By the time Georgia and Aunt Dora arrived for dinner, Harold and I had decidedly won. After dinner, Dad kissed the top of my head and tousled my hair. "It's bedtime for my little winner."

"Oh, Lucky," I said, leaning down from my bed to give him a hug. "This has been a most wonderful day." Lucky gave me a lick and curled up on the rug.

Ancient Temple

Dad had a special place he liked to take energetic visitors—an old fishing village overgrown by jungle. The stone foundations were still visible, and, over the years, he'd found a *poi* pounder and several stone axe heads there. A few months earlier, while hiking with Harold, he'd discovered a large round stone with vertical grooves all around it. It was so heavy that even taking turns, it took three trips to get it to the car.

"I described it to the curator at the Bishop Museum," Dad told Georgia after breakfast. "He thought the stone must have been tied onto a club to smash enemy canoes. He asked if I would donate it to the museum. I hated to let it go, but it's an unusual item and it seemed proper for them to have it."

"Fascinating," Georgia said. "I'm eager to hike there."

As we left the house for our excursion, Lucky wagged his tail and looked hopeful. "Can he come this time?" I asked Georgia.

"Will you hate me forever if I say no?"

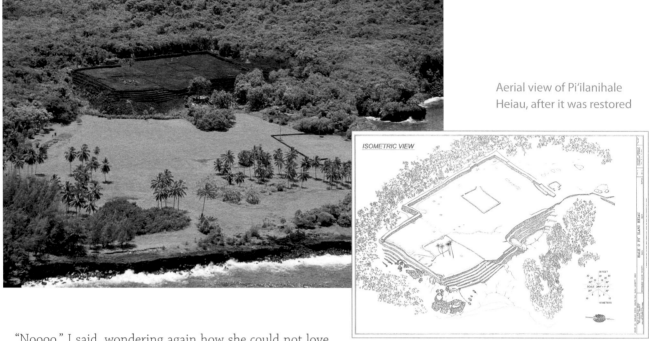

Aerial view of Pi'ilanihale
Heiau, after it was restored

Isometric view of Pi'ilanihale Heiau

"Noooo," I said, wondering again how she could not love Lucky.

Dad and Georgia sat in front, and our gardener Sato joined me in the backseat. He came along to drive the car to the spot where we'd finish our hike.

The forest in Upper Nāhiku was thick, but the steep trail down to Honomā'ele Gulch was well worn by local fishermen. A small stream tumbled down nearby, amidst the intoxicating smell of ripe guava. I picked one of the pink-orange fruits.

"These are really sweet, Georgia. Would you like to try one?"

"All right, you choose it." She took a bite. "It tastes fine, but are you sure they're not filled with buckshot?" referring to the mass of pellet-like seeds inside.

Dad laughed. "I don't think you've made a convert, Pat."

I continued eating guava after guava as we walked down the steep trail. We stopped once along the way to explore the rock foundation of an ancient Hawaiian home. "This is where I found a *poi* pounder," Dad said.

At the bottom of the hill, the trees were mostly *hala*, whose leaves (*lauhala*) the Hawaiians use for mat weaving. Large clumps of *naupaka* lined the shore. The trail branched near the ocean, and Dad led us to the left. After a short distance on

Right: Trail through guava tree forest, Kīpahulu, Maui

Above and below: Guava fruit and blossom

the trail, a small creek crossed our path. Although it was only a few feet wide and perhaps three inches deep, when Georgia stepped into its cool waters, she lifted her foot quickly and said, "I can't cross that."

"It's very shallow, and the village ruins I'd like to show you are this way," Dad urged. "I'll cross first and Pat and I can hold your hands to steady you."

Georgia's hand trembled as we took two steps into the ankle-deep water.

"No, I can't do it," she blurted.

I was dumbfounded. How could anyone be frightened of that little trickle?

"I'm afraid Patricia is disappointed in me," she said quietly.

Before I could respond, a sharp pain jabbed my stomach, and I pressed it with both hands.

"Are you all right?" Georgia asked.

"My head and tummy hurt."

"Willis," she said, "why don't we stop and rest in the shade until Patricia feels better?"

I gratefully sat down and, still hurting, hung my head. Georgia sat beside me and gently massaged my neck.

"How many guavas did you eat?" Dad asked, but before I could answer, I leaned into a *naupaka* bush and threw up.

Georgia walked back to the creek, wet her handkerchief, and tenderly wiped my face. I felt touched by her caring and concern. "Patricia must have had too many waffles at breakfast," she said, winking at Dad. "How do you feel now?"

"Fine, I guess. Since we didn't go to the village, can we show Georgia the stone walls you say must have been a *heiau*?"

"We'll see. That part of the trail is in the sun and we don't want to exhaust Georgia."

"Let's try," Georgia volunteered.

After walking a bit, we saw glimpses of rock walls in a dense growth of *hala* trees.

"I feel pretty sure it is a *heiau*, an ancient place of worship," Dad said. "It's tempting to bring down a cane crew to clear it, but the work should be done by archaeologists. We'll leave it alone for now, but I wouldn't be surprised if this is the largest *heiau* in all of Hawai'i." Decades later, when the stones were cleared and the building restored, Pi'ilanihale Heiau turned out to be the largest native temple in all of Polynesia. After exploring the area a bit more, we walked slowly back up the slope to where Sato was waiting for us with the car.

"This is my last day in Hāna," Georgia said wistfully.

Father took her hand and squeezed it. "You'll just have to come back."

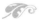

"I Could Let You Watch"

The next day, Dad and I drove Georgia to the Maui Grand Hotel in Wailuku, stopping along the way at Wailua Point to look at the Catholic church that had a bleeding heart painted over its entrance and the beautiful, water-filled taro patches. We ate lunch at the water's edge, watching massive waves of bright white froth crash onto the black lava rocks.

Harold had reserved three rooms for us at the Maui Grand. He kept a permanent room there, but was away

Robert Lee Eskridge (1891-1975)
Wailua Catholic Church
Watercolor
22 x 13 1/4 in. (55.9 x 33.7 cm)
Collection of Monica Jennings

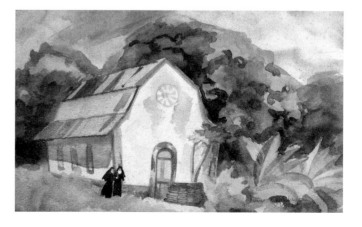

Maui Grand Hotel, c. 1940
Photo courtesy of Maui Historical
Society

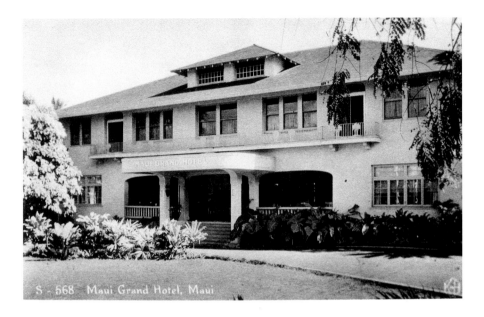

S - 568 Maui Grand Hotel, Maui

*I am glad I came—I could
stay right here on this island
for two or three months and
like it—a country hotel that
is comfortable—clean—
food quite alright—nothing
fancy—the people amuse
me when I have time to walk
down the street—there is a
church I'd love to paint and
wonderful trees—not many
tourists.—There are cane
fields—a sugar mill—I'd like
to try to paint both—there
is my green valley—and I
haven't even started looking
at the volcano—Just a quiet
little town—a bit quaint and
queer—*

—Georgia O'Keeffe in a letter to Alfred
Stieglitz, March 23, 1939

at Boy Scout gatherings on Moloka'i and Lana'i. In the evening, we had a quiet dinner in the hotel dining room.

The next morning, Dad arranged for Georgia to drive a rental car, with me as her guide, while he attended a business meeting. A cheerful Filipino man greeted us in front of the hotel and showed Georgia a clean, though rather ancient, Chevrolet with the gearshift on the floor instead of on the steering column.

"I can't possibly drive that!" she shrieked, standing on the hotel's front steps. "Get me another car at once!"

Her outburst startled me. Oh dear, I realized, she's being difficult.

"This one good car," he insisted. "You try."

"No. Get me something else."

"I no got nothing else. You try. Very easy to drive."

"I said get another car!" Georgia was practically shouting. Passersby had begun to stop, and in the thick of battle, the hotel manager came out.

I had never felt so embarrassed. The rental clerk seemed close to tears as he explained to the manager that he had only two rental cars and the newer one was in use. The manager tried to explain to Georgia that no one else in Wailuku rented cars, but she continued to insist. I could stand it no longer

and, summoning up my courage, I looked at Georgia and said, "I think you can drive it."

She looked startled, then she smiled. "Well, if Patricia thinks I can drive it, I shall."

The manager expressed great relief; and, for a moment, I thought the clerk was going to kiss me.

After a little practice with the gearshift, we set off for 'Īao Valley, a lush gorge in the West Maui Mountains a few miles outside of Wailuku town. The wind was still, and the only sounds were birdsong and the stream coursing over boulders through the valley. To our right, a waterfall plunged several hundred feet down a vertical valley wall.

"Kamehameha the Great fought an important battle here in the eighteenth century," I explained. "He defeated the Maui chief. Then he won battles on O'ahu and united all the islands."

"This looks like a good place to stop," Georgia said, pulling the old car over. "Can you keep yourself busy for a bit?"

"Okay," I nodded.

Georgia set up her easel a few feet from the car while I eyed some ripe guavas across the river. This time I thought it better not to try to cross.

After ten minutes, a light drizzle dampened the air, but Georgia seemed oblivious. Then it began to pour. I ran to help her get her things into the backseat of the car, and, to my surprise, she climbed into the backseat, too.

"When I'm in New Mexico, I often paint from inside my car. The sun gets too hot in the desert. Now turn around and sit quietly."

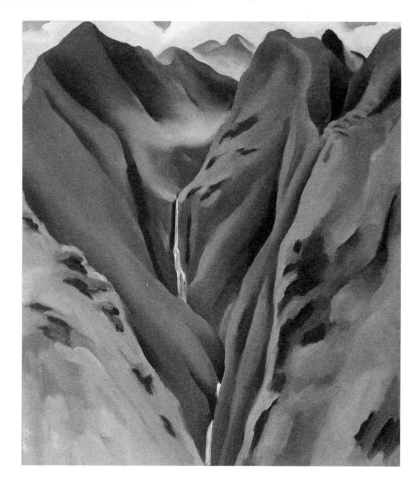

I sat slumped in the front seat and watched the rivulets running down the windshield. I was hungry and wished I'd picked a guava after all. I longed to peek over my shoulder but didn't dare. When I shifted a bit to stretch my legs, I jarred the seat and Georgia sighed. I crossed my arms over my chest, trying not to move.

A moment later, she said, "I suppose I could let you watch—but absolutely no talking."

I turned around slowly and knelt on the front seat with my arms resting on its back. Georgia, perched on the edge of the back seat, gazed intently out the

'Īao Valley, Maui

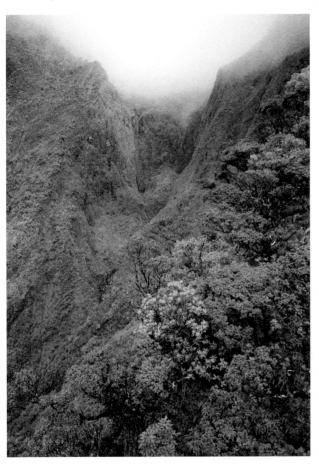

side window. Her deft fingers made the green oil paints flow effortlessly into place, and I could see the valley walls and waterfall emerging on the canvas. Just as she was switching colors, the rain became torrential and our view of the cliffs disappeared.

"Doesn't look as though it's going to stop," she sighed, setting down her brush. She seemed satisfied with what she had done, and she turned to me and said, "You know you are a very privileged girl. I never let anyone watch me work."

I was elated beyond description, and suggested, "It probably isn't raining outside the valley. Would you like to go someplace else?"

"No, thank you, Patricia. I can do a bit more this afternoon at the hotel, and I'll come back here another day. Why don't we have an early lunch?"

I bounced in my seat, rocking the car. Lunch with Georgia at the Maui Grand Hotel would be pleasurable indeed!

After lunch, she returned to her room to paint, and I walked down the block feeling rich clutching the five-dollar bill Dad had given me. I browsed first in the Kress 10-Cent Store but found nothing of interest, so I went to the Maui Book Store. To my delight, there were two Nancy Drew novels I hadn't read. I purchased them both, went back to Kress's for a Hershey's Almond Bar, and strolled happily back to the hotel with my treasures.

That evening, Harold joined Dad, Georgia, and me for dinner. Georgia was

fascinated to learn that Harold had a scout troop at Kalau-papa, the leprosy colony on Molokaʻi.

"Tomorrow we're taking Georgia to see the sunrise on Haleakalā," Dad told Harold. "I'm sure you won't want to miss that," he added with a smile. He knew that every time Harold had been up the mountain, the crater had been hidden by fog. I explained to Georgia that if you don't find Haleakalā clear your first trip, you're supposed to try nine more times.

"No, thank you," said Harold. "I'll stay in my warm bed while you all freeze. Besides, we're due at Dora's for brunch at eleven. Kula will be chilly enough."

H - 135. Haleakala Crater, Maui

Georgia O'Keeffe to Alfred Stieglitz, postcard picturing Haleakalā Crater, Maui, March 10, 1939 Yale Collection of American Literature, Beinecke Rare Book and Manuscript Library, Yale University

"Patricia's First Snow"

We began our early morning journey in the pitch black, winding up the narrow Haleakalā mountain road to the ten-thousand-foot summit. It wasn't windy, just icy cold, and there were patches of snow along the road. As we neared the mountain-top, we saw a light on in the National Park observation hut. Fog was rolling in, and there was even more snow in the parking area. Dad grabbed the sack of doughnuts

*Next morning Patritia [sic]
and Mr. Jennings and I
started for the volcano rim at
10 to four—dark of course—
to see the sun rise—well—we
didn't see anything but fog
and rain and patches of
snow—but on the way down
in the day light the fields
and hills and ocean and near
islands all floated out in the
clouds like a fairy story—it
was very beautiful—*

—Georgia O'Keeffe, in a letter to Alfred
Stieglitz, March 23, 1939

Clearing snow from Haleakalā Road
after storm, February 5, 1936
Photograph by Park Ranger J. A. Peck
Courtesy of the National Park Service
Haleakalā National Park Archives

the Maui Grand had provided, and we hurried toward the lighted building.

"Good morning," the park ranger said. "You're brave to venture out so early."

"We're hoping to see the sunrise," Dad replied. "Any chance of that?"

"If the wind comes up, it could blow the fog away. Would you like some hot chocolate while you wait?"

"Oh, yes!" I blurted out. Georgia and my father laughed.

We looked at the photographs on the wood-paneled walls and the park's plaster model of Haleakalā Crater. "Kaupō Gap is closer to the Hāna side," Dad explained, pointing to the broad valley spread out of the crater's southeastern side. "We mule ride in and out of the crater from Kaupō. There are three cabins in there for overnight stays."

As we chatted, clutching our warm mugs, the pot-bellied stove in the corner hissed.

"Why does chocolate stay hot longer than tea or coffee?" Georgia asked. No one seemed to know, but we were glad for it.

"Dad, can I make a snowball?"

"Have you seen snow before?" Georgia asked.

"I see it on Mauna Kea across the channel every winter, but I've never touched it," I said, hurrying out the door.

The sky, still dense with fog, was growing lighter. I grabbed a couple handfuls of snow, formed them into a ball, and dashed back inside to show my frosty prize.

"Do you think Madame Pele would like it if I threw her a snowball?" I asked the ranger.

"I don't know," he laughed.

I ran outside and wished for the crater to clear so Georgia could see the vast beauty. Then I threw the snowball into the mist.

"I'm afraid we're wasting our time," Dad said, giving up on the fog clearing. "Dora and Alexa will forgive us if we arrive a bit early. I've had enough of this cold."

The ranger pointed to the guest book. "Please sign before you go."

Georgia signed her name, and, in the comments section, she wrote, "Patricia's first snow."

Alexa von Tempsky Zabriskie and
her English spaniels. Kula, Maui,
c. 1940
Photo courtesy of Patricia Jennings

Dangerous Dan McGrew

We drove from the summit of Haleakalā down to Upper Kula road. The von
Tempskys' house was at four-thousand feet, and, in winter, it could be quite cold
there. The long driveway—two strips of concrete—traversed the pastureland
and went right up to the gatehouse, which doubled as a car garage. Alexa's studio
was above the garage. We parked near the brick path to the house, and six of
Lucky's relatives dashed out to greet us.

"Goodness! They do multiply," Georgia said dryly. But she was duly impressed
when Alexa shouted, "Sit!" and the spaniels all dropped to the ground.

Aerial view of Maui coast

…we were invited to a house half way up the volcano …huge open fire places with roaring fires—in all the rooms—a house like nothing else I've seen—sort of elegant and free—but all held well in hand—

—Georgia O'Keeffe, in a letter to Alfred Stieglitz, March 23, 1939

The fresh smell of eucalyptus mingled with the faint scent of wood smoke, and I took in a deep breath. The von Tempskys' Tudor-style house was my vision of heaven.

We climbed the steps to the small verandah. By the entryway stood two pairs of tall rubber boots alongside two miniature pairs, which Georgia looked at inquisitively.

"Those are Jed's," Alexa explained, "for wet weather."

Georgia laughed, "I've never seen dog galoshes before, not even on Park Avenue."

We followed Alexa inside. I loved everything in Aunt Dora's house—the entry hall's bearskin rug, its teeth bared; the antique English furniture; the towering ceiling; and, best of all, the views of Kīhei, Māʻalaea, and the West Maui Mountains. When we would spend the night, I'd sneak to the balcony over the living room and listen to the grownups talking as they sat around the fire. The dining room fireplace had built-in seats on both sides. There was an antique mahogany table that extended to seat twenty people, and, above the table, a bronze nymph sat atop the vine-shaped chandelier that had been converted from gas to electricity.

Eight of us gathered in the living room: Aunt Dora; Alexa and her brother Robert, who everyone called Boy; Boy's wife, Mameʻa; and Harold, Dad, Georgia, and me. Jed curled up in front of the fire, and I sat on a low stool beside him, sipping mulled cider while the adults chatted over hot toddies.

When Masa, the von Tempskys' Japanese maid, announced that brunch was served, Jed led the way into the dining room and settled at his spot in front of the fire there.

Tall, gray-haired Boy, with a deep dimple in his chin and a twinkle in his eye, offered to say grace.

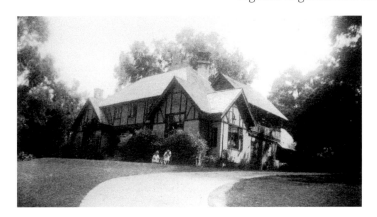

Home of Dora von Tempsky, Kula, Maui, c. 1939
Photo courtesy of Patricia Jennings

"Not the Cowboy's Prayer!" his sister Alexa exclaimed. "By the time you finish, the food will be cold."

"Oh, please do," I begged. I loved hearing Uncle Boy recite poetry, any poem,

even a really long one. He had an emotional way of reading and seemed to believe every word.

"Thank you, Patty dear," he said with a grin, and stood up. "You shall have it."

> Oh Lord, I've never lived where churches grow.
> I loved creation better as it stood
> That day You finished it so long ago
> And looked upon Your work and called it good.
> I know that others find You in the light
> That's sifted down through tinted window panes,
> And yet I seem to feel You near tonight
> In this dim, quiet starlight on the plains.
>
> I thank You, Lord, that I am placed so well,
> That You have made my freedom so complete;
> That I'm no slave of whistle, clock or bell,
> Nor weak-eyed prisoner of wall and street,
> Just let me live my life as I've begun
> And give me work that's open to the sky;
> Make me a pardner of the wind and sun,
> And I won't ask a life that's soft or high.

from Charles Badger Clark, "A Cowboy's Prayer"

Dora von Tempsky with Jed, the father of Patricia's dog Lucky
Photo courtesy of Patricia Jennings

Uncle Boy went on to recite the entire poem from memory. Then, as we began eating, the outdoor dogs started to howl. Aunt Dora rang the bell for Masa, who hurried back into the dining room.

"Call the dogs in! We don't have to listen to that racket."

Masa dashed to the verandah door and said, in a slightly raised voice, "Doggie come! Come, doggie!"

Georgia looked aghast as six silky-coated spaniels bounded into the dining room.

Aunt Dora clapped her hands. "Go to your places at once!" and each dog found a spot along the wall while their father, Jed, ignored them all.

Boy and Alexa were in good form that day, telling amusing family stories,

and Harold was his usual witty self. It was well into the afternoon when Dad announced that we needed to head down the mountain.

I piped up, "Uncle Boy, will you recite 'The Shooting of Dan McGrew' for Georgia before we leave?"

Boy laughed and began reciting from his place at the head of the table:

Robert "Boy" von Tempsky
Photo courtesy of Debbie von Tempsky

> A bunch of the boys were whooping it up in the Malamute saloon;
> The kid that handles the music-box was hitting a jag-time tune;
> Back of the bar, in a solo game, sat Dangerous Dan McGrew,
> And watching his luck was his light-o'-love, the lady that's known
> as Lou.
> When out of the night, which was fifty below, and into the din and
> the glare,
> There stumbled a miner fresh from the creeks, dog-dirty, and loaded
> for bear....
>
> *from Robert W. Service, "The Shooting of Dan McGrew"*

He went on for ten minutes, reciting this whole poem, too.

"What a delightful family the von Tempskys are," Georgia said as we drove away. "And you know, Patricia, I doubt Harold will ever marry Alexa. His life as a charming bachelor must be very pleasant."

A Fond Farewell

After a farewell breakfast with Georgia at the hotel, we had to return to Hāna.

"Patricia," Georgia said after we finished eating. "I want to take you into the gift shop, and I'd like you to pick out something you really want."

The Maui Grand Hotel's gift shop was by far the nicest on the island, and I had often longingly studied the Chinese porcelains, ivories, jades, silk robes, and jewelry. A few weeks earlier, I'd seen a pair of satin Japanese *tabi*, socks designed for wearing with sandals. Mother said they were a ridiculous price at over five dollars—the cotton ones I wore for dinner every night cost just a few cents. Besides, she said, I would probably ruin the satin in no time.

How wonderful to be able to get something I wanted, but what if I chose a gift

that cost too much? That would be most embarrassing. "Everything there is so expensive," I replied.

"Come along," Georgia encouraged me. "We'll find something."

"Don't be too long," Dad cautioned, "It's Monday. The road gangs will be out today, and there might be delays on the way home. I'll check us out of the hotel and pick up our lunches."

I was thrilled to be in the Maui Grand gift shop with Georgia and immediately went to the shelf of satin tabi. I spotted a green and rust flowered pair that would be perfect with my favorite Chinese silk pajamas.

"Is that what you really want?" Georgia asked.

"Oh, yes," I said, delighted.

"Well, that isn't enough. What else would you like?"

I wanted to ask the price of a jade ring, but surely that was too expensive. Then I saw a choker of tiny Niʻihau shells with a carved ivory clasp. "I'd like this if it isn't too much."

"That will be fine," Georgia said, patting my back. "Please don't worry."

"Thank you so much!" I said, throwing my arms around her.

When Dad and I left the hotel, Georgia came out to the car to see us off. She reached for Dad's hands and held them for a few seconds, then said, "Please give Bob Eskridge the easel and paints I left."

Then she turned to me. Looking intently into my eyes, she said, "Patricia, you are a very special young lady. Don't you ever forget that. I want you to promise to tell your mother what I said. She should be very proud of you. Will you do that for me?"

I nodded, sadly, and Georgia hugged me and warmly kissed my cheek.

My father and I got into the car, and as we drove away, Georgia waved with those beautiful hands.

"I'm going to miss her," I told my dad.

"I'm happy you enjoyed her stay," he said.

"I'm glad Mother wasn't here. Georgia O'Keeffe is now my own special friend."

Dad smiled thoughtfully and patted my knee.

Reflections

After Georgia O'Keeffe left Maui, I was lonely indeed. The days seemed endlessly quiet. I loved having my father all to myself—it was another month before Mother came home—but I dreaded the home-schooling lessons that awaited me on her return. Finally, one evening, after a game of cribbage with my father, I gathered my courage and spoke my mind. "I know I'm not supposed to start Punahou until ninth grade, but that's a year and a half away! I don't want to spend another year with Mother's lessons. I hate them!" I said, and burst into tears.

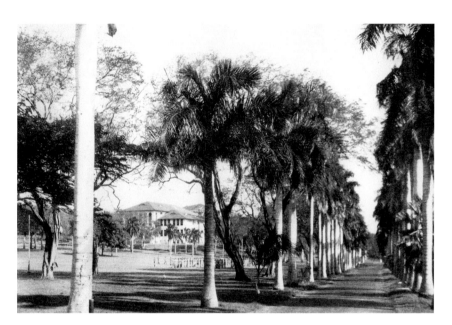

Punahou School, Honolulu, c. 1940
Photo courtesy of Bishop Museum

To my surprise, he put his arms around me and said, "If that's what you want, I'll look into it." Punahou was a private school in Honolulu founded by missionaries in the nineteenth century. It had a boarding department for outer-island children. When Mother came home, to my relief, she never mentioned our unfinished schooling.

In June, my sister Monica came home from college. She spent most weekends partying with friends on the other side of the island, and even when she had two large parties at our house, I was pretty much left out.

A week before I was to begin Punahou, Mother and Monica took me to Hono-lulu to shop and have a medical exam. The doctor, appalled that I'd never had a smallpox vaccination, gave me the injection under my arm. "It's the newest way to do it," he told Mother, "and it leaves almost no scar."

I was then deposited at Punahou. My roommate, a year ahead of me, disliked me on sight and did everything she could to make my life miserable, even short-sheeting my bed several nights. She had her own circle of friends, and I was completely left out. I swallowed my tears and my pride, and said nothing.

I was also afraid to tell my teachers that this was my first taste of formal school. Then, a week after classes started, I came down with a high fever. The injection area of my left arm had become swollen, red, and oozing, and I spent ten weepy days in the infirmary, which was a disaster for my schoolwork. In the first six weeks I flunked everything but English and was told my work "showed a lack of pride." I was so ashamed I wanted to die.

Then I thought of Georgia. She had said I was special, and I clung to that affirmation. For the first time in my life, I worked hard, and the next grading period I got an A in English and a B plus in math.

The boys and girls boarding at Punahou had dinner together every night, seated separately at opposite ends of the old Dole Hall. After dinner, for half an hour before study hall, we were permitted to mingle on the *lānai*. One evening, a good-looking boy from Hilo, three years older than I, came up and spoke to me. He asked if I was from Hāna and said that his grandfather had some connection to the old Kīpahulu Plantation. I was elated at our mutual link and even more that he had spoken to me!

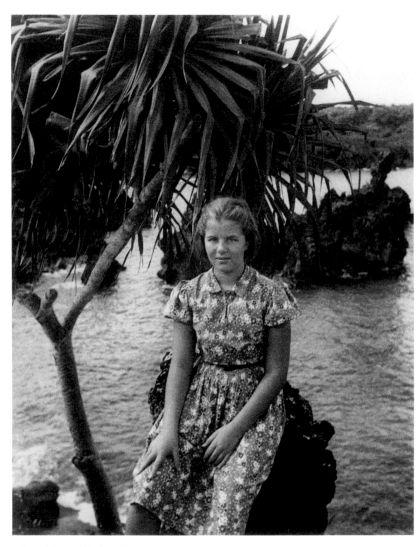

Patricia at Wai'ānapanapa, age 12
Photograph by Harold Stein
Courtesy of Patricia Jennings

When I got back to the dorm, a group of girls, including my roommate, descended on me. "What did he say?" "What did you talk about?" "Isn't he dreamy?" It was a turning point, and at last I was accepted. A few weeks later, to my complete surprise, the same young man, a junior, asked me to go to the school dance with him, quite a coup for an eighth grader. Of course, I had lost fifteen pounds by then, mostly in the infirmary, and perhaps that helped.

I never saw Georgia again, although my parents did see her in the 1950s, when she visited Honolulu. I wrote to her before I entered Punahou School and got a nice letter back, something about boarding school being a new adventure and how much I must miss Lucky. I wrote again in January after Aunt Dora died, and she responded, calling Dora a "charming, gracious, and courageous lady." Both letters are now lost, but by some miracle I do have a third one she wrote, a year later, in May 1941.

Unbeknownst to me, Mother had sent Georgia a picture of me at age fourteen, and that prompted her to write. That letter was in my desk in the Punahou dorm on December 7, 1941, the day the Japanese attacked Pearl Harbor. My parents were in Honolulu for the weekend, and I was staying with them at the Royal Hawaiian Hotel. When martial law was declared that Sunday, the Army Engineers, mistaking Punahou for the University of Hawai'i, took over the whole campus. My possessions were tied up in my sheets and thrown into the basement, along with everyone else's. Amazingly, six months later I got all my belongings back, including Georgia's letter. I put the letter in my desk at home in Hāna and forgot about it. Several years later, when my parents moved to Honolulu, they sent all the things I'd left at home to St. Louis, where I was then living with my husband and children. When our family moved back to Maui in 1962, I was sorting out boxes and, to my delight, rediscovered Georgia's letter:

<div style="text-align:right">405 E. 54 – N.Y.
May 1 – 41</div>

Dear Patricia:

Your picture came to me after a very round about trip. You had my address wrong but I got the photograph anyway. I suppose I got it because it was intended for me. It is very nice to see you again—you must be quite a young lady by now—Of course I will always remember you as a little girl—a very lovely little girl—in a sort of dream world.

I have wanted so much to go back to the islands the past two winters but it is a long way to go and we seem so aware of the War here that the States seem the best place to be. I wonder if you came to the States last summer as you intended—I thought I might hear from you then I didn't.

Oh—I wish that I could go for one of those fine walks with you again— and

I remember the day Harold Stein took that picture. Mother and I had just returned from the summer in California, where I had my twelfth birthday, and Harold said he wanted to take some pictures of me. We went to Wai'ānapanapa and he took several. He presented Mother and Dad a matted copy of this one.

—Patricia Jennings

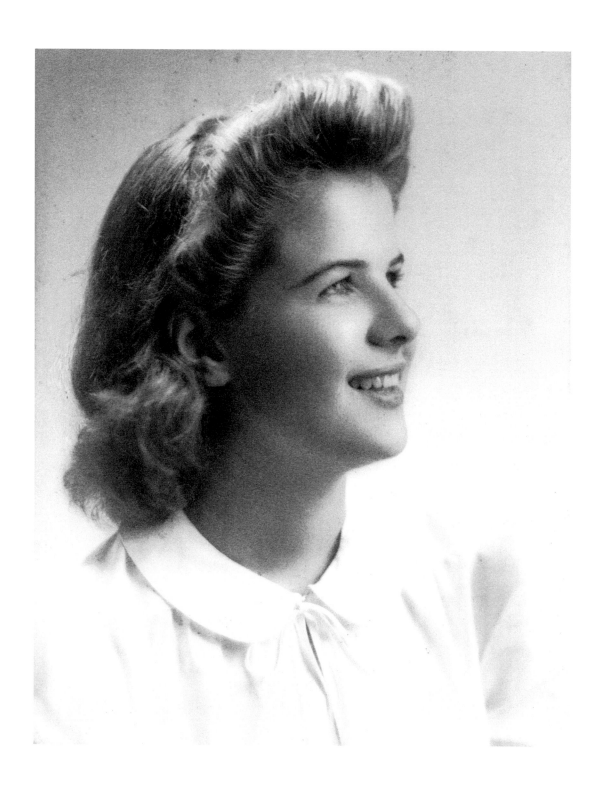

see you sitting there at the head of the table so young and so dignified—It was very nice. If you ever come to the States you must let me know.

Thank you so much for the photograph—I wonder if you wear shoes comfortably once in a while nowadays.

Fondly,

Georgia O'Keeffe

She was right. We had been living in a dream world. The war changed everything. The days I spent with Georgia O'Keeffe left an indelible mark on the rest of my life. When Georgia visited us in Hāna, I enjoyed hearing about her growing up in a big family and resolved right then—at the age of twelve—to have a big family too. I have been blessed with five wonderful children, nine grandchildren, and three great-grandchildren—the joys of my old age. I also learned from Georgia that if you start something, finish it, and that even the nicest people have faults and you can love them anyway. But the deepest gift she offered me was the experience, in some way for the first time in my life, of really being listened to and appreciated for who I was. That influenced the way I raised my children and helped me through the rest of my life. I am forever grateful for having had the chance, at the age of twelve, to host and guide Georgia O'Keeffe on Maui.

The author at age 14
Photo courtesy of Patricia Jennings

405 E. 54 ~ N.Y.
May 1 ~ 41

Dear Patricia:

Your picture came to me after a very round about trip. You had my address wrong but I got the photograph any way. I suppose I got it because it was intended for me. It is very nice to see you again - You must be quite a young lady by now ———— Of course I will always remember you as a little girl ~ a very lovely little girl ~ in a sort of dream world.

I have wanted so much to go back to the islands the past two winters but it is a long way to

go and we often so aware of Nan here that the States seem the best place to be. I wonder if you came to the States last summer as you intended — I thought I might hear from you then I didn't.

Oh — I wish that I could go for one of those fine walks with you again — and see you sitting there at the head of the table so young and so dignified — It was very nice. If you ever come to the States you must let me know.

Thank you so much for the photographs — and I wonder if you wear shoes comfortably once in a while nowadays. — Fondly
Georgia O'Keeffe

Letter from Georgia O'Keeffe to
Patricia Jennings, May 1, 1941
Courtesy of Patricia Jennings

Georgia O'Keeffe writing a letter,
Yosemite, California, 1938
Photograph by Ansel Adams
Yale Collection of American
Literature, Beinecke Rare Book and
Manuscript Library, Yale University
© 2011 The Ansel Adams Publishing
Rights Trust

MAUI GRAND HOTEL

WAILUKU

ON THE ISLAND OF MAUI
TERRITORY OF HAWAII

PHONE 2 WHITE 80
CABLE AND WIRELESS ADDRESS
"MAUIGRAND"

E. J. WALSH, Manager

HONOLULU MAR 27, 1939

Georgia O'Keeffe, Letters to Alfred
Stieglitz, March 25, 1939, page 1,
and March 30, 1939, page 5
Yale Collection of American
Literature, Beinecke Rare Book and
Manuscript Library, Yale University

GEORGIA O'KEEFFE'S
Letters from Maui

While she was in Hawai'i from February through April 1939, Georgia O'Keeffe wrote twenty-three letters to Alfred Stieglitz, eight of them (including one postcard) from Maui. The full collection of her Hawai'i letters is in the Beinecke Rare Book and Manuscript Library at Yale University. These letters were not made public until 2006, twenty years after her death.

O'Keeffe rarely used standard punctuation, mostly employing wavy lines to separate her thoughts and sentences. In the following transcription of her Maui letters, these marks are represented by long dashes. We have retained her original spelling and punctuation throughout.

Friday, March 10
Picture postcard (photo of Haleakalā)

This seems to be the best yet—The trip over by plane was fine—I will be off in the far away place where—but every one says is the good place. The flying was very good and I am fine—9 in the morning on a new island seems good. Wish you could see it.

Monday, March 13 – Hana

Mr. Stieglitz—

You would laugh to see where I am now—Almost at the end of the road on Maui—a little sugar plantation town—at the managers house—the only white family for 60 miles and it is different as the man in Honolulu told me it would be. The mans wife is not at home but his daughter is—a very wise little blond girl of about eleven—…

—It is sixty miles in the country—up the coast—It is queer country—hard to describe because it varies so—and all the foliage changes—sometimes

grass—sometimes cane—sometimes bamboo—in some places great spaces of very steep high cliff like hillsides covered with small ferns and many of the tree ferns standing out sort of singly—there are many water falls—masses of rank trees and bushes—all new to me—It was a nice drive—up and down hill—around bends—always the sea with usually its black rim of lava at the edge—

We got here for lunch—a house that rambles about—feels more like the Virginia plantation sort of thing down on the James River used to be [sic] feel and still it is entirely different—Mr. Jennings is difficult to describe too— Has some 620 people working on the plantation and in the sugar mill and all the problems and situations that go with such a situation. He is about 45 I'd say—came out here in his teens and stayed—is from Pennsylvania—very quiet and gentle at home—but I notice that when he speaks to the men he means it—there is nothing uncertain about it—Sugar certainly takes on a new significance when you see it this way.

The first afternoon I was here he took me with the little girl down a beach looking for shells and to show me the beach—It rained— but it is as they told us before I came out here—the rain doesn't seem to make you wet—We got behind a rock or a pile of wood—and in a few moments the rain was gone—I went to bed very early that night—was very tired. The next morning he gave me an old Ford to go out and look around in. I went over every place he had taken me and on to some more—a beautiful strip of black lava stretching out into the sea—worne under in one spot so it was like a bridge—…

This morning we all drove on up the road—the steepest roads I have ever gone up and down till we got to a place almost the end of the road—and what a view—ocean behind us and ten thousand foot mountains in front of us and the valleys in them are most startling—The slope to the sea in one direction was so beautiful—the long even line of the top of a lava flow miles long—many waterfalls way up on the mountain that must be very big falls—We had lunch out on the grass at the edge of the black lava by the ocean—The lava so very black—the sea pounding in on it—blasting through holes in it—several holes you can look into and see the water come and go way under

Natural Stone Arch, Wai'ānapanapa
State Park, Hawai'i, 1939
Georgia O'Keeffe
Photographic print
2 1/2 x 2 7/8 in.
Georgia O'Keeffe Museum
Gift of The Georgia O'Keeffe
Foundation (2006-06-1096)
© Georgia O'Keeffe Museum

ground—then we went through a cave and out on a rock and sat there a long time watching the foamy white waves breaking on the black black sand and all the fantastic black lava shapes out beyond in the water.—In the little bay was an old Hawaiian boat shelter made as they formerly made their houses with three old hand made canoes in it—fishnets out to dry in front of it—… —when we got back to the house I was dead for sleep and slept—

It is hard to tell about the islands—the people have a kind of gentleness that isn't usual on the mainland—I feel that my tempo must definitely change to put down anything of what is here—I don't know whether I can or not—but it is certainly a different world—and I am glad I came. I wish you could see the black sand and the black lava with the sea—and the high mountain country that we saw this morning—…

Wednesday, March 15 – Hana
Wednesday A.M. 6:45

… Yesterday I went out painting in the morning—a little thing about 4 x 6 —The sun and the general difficulties make me not want to try anything big— The most exciting thing here is the black lava shapes along the water and the cane fields—The lava does all sorts of queer things as it touches the water and its blackness with a little bright green on it is startling against the blue and foaming white of the water—

The cane fields are everywhere it seems—run way up on the mountain— some of them on astonishingly rough land—every night we drive out to see where they are loading and bringing cane in by artificial lights—The big derrick and trucks and men—always some one on horse back moving about in the dim light is spectacular—and driving at night around the cane fields is very beautiful—often it is along the ocean—Night before last we went through the sugar factory—… The day before we drove late in the afternoon down to the most native sort of Hawaiian villages I have seen—way down through the jungle by the water—It is real country here—but I like it—Mr. Jennings a very nice person—Loves the country and has such good places to like and to take one to—The child likes it too—There is also a dog—We really have a very good time…. I must say I feel far away in another world here—

Saturday, March 18 – Hana

Saturday morning— Good morning—

It is really so nice here—country—quiet—busy—busy with so many differ-ent kinds of things—still the man has time to take Patricia and me some place scrambling over rocks every afternoon—this even climate is some-thing I don't seem to be able to understand—even tho it goes on day after day—Yesterday afternoon we must have walked a couple of miles along the coast—always we go to a new place—the lava makes a crazy coast—black with the bright blue sea—pounding surf rising very high in the air in many places—queer formations worne in the lava—bridges—gate ways—holes through it where it seems solid where the water comes up in spray—hissing and blowing—

And I feel so good I love coming about over it—I love the wind and the salt air—quite salty spray where you walk the coast and the wind is from off shore.

We climbed down through jungle too to go to some caves where there is fresh water and you can swim underground from one cave to another—and we all like it—all… I have two paintings here—a big one that is good and a little one that is fair. I think the big one really quite good.…

I sit up nights talking with Mr. Jennings when I might be writing but he is interesting and it adds to every thing—He has been very nice in a special way of his own that makes being here very nice and very interesting.

By the time I leave the islands I am going to know so much more about sugar than I do about pineapples that is funny—…

A kiss to you—I am feeling fine—…

Monday, March 20 – Hana

Monday morning—In an hour or so I'll be leaving Hana—I hate to go—It has been lovely here—quiet—only the excitement of what three people can do in the country—60 miles from town—The sugar town is a town of mixed yellow people—The movies about the only form of city entertainment—It is so funny to step out the door of the movie house and have to take a long step up a lava bank to the street—then to see the pairs of dark people moving off into the night in all directions—just a few cars—

It seems no one has taken so much trouble—no not exactly trouble—I should say that Mr. Jennings has been extremely nice and careful thinking for me—He has made me feel that he enjoyed it too in a very quiet, alert—interested fashion—The child too is so lovely—a flower in full bloom with the sun on it—

Every day they have taken me to a different kind of a place—late in the

afternoon—we have walked and climbed—and sat in the sun—and always the places were so good—

Yesterday we went out at about ten—took lunch—came back at about 2:30—It was such a sparkling sharp sea—often through these Luhalla *[hala]* trees—a busy sort of palm—thick enough with foliage to be a house—not very tall—good thick shade under them—

Then in the late afternoon went to the good sandy beach and all went in the water—dog and all—the air and sun and water all just the right temperature—And such lovely trees and bushes—all big leaved right at the edge of the sand—rocks rising up behind the trees—green covered rocks—A beach about three long blocks long but quite perfect

Maybe this even temperature would get you down in time but so far I've loved it—

Tonight we go to a house up on the side of the volcano—4000 feet up for dinner—and tomorrow night I take the boat for Hawaii—I drove out early this morning—through the cane—along the sea—early light on the mountain tops that are often in cloud—some way feeling that I would never experience anything like it again—

The cane fields sort of get under my skin—sort of fascinate me—and every day I learn more about them—When you get snatches of the sea through the sharp softly waving leaves it is really lovely—

This morning they were burning a field—the fire crackling—and the thin smoke in the wind across the mountain—and always the smell of it—sometimes so strong it has waked me in the night

And always you are aware of Willis Jennings with his mind on his job in a determined reasoning—and sometimes dreaming sort of fashion

Every morning we listen to the news on the radio before 7:30 breakfast—It sounds pretty hectic and I can imagine that more out in the world than this you are all in a rather excited state…

I have three paintings from here—one big one of white flowers—It has been funny to see the way it made them all open their eyes—and two of the lava with the sea—am sorry that I got no cane. One of the lava sea is 20 x 24—the other about 4 x 6—The flower 30 x 36—

It is raining—I came in this rain and it seems that I will go in the rain. Until now 10:10—it has been a beautiful morning but I could see the rain out at sea—when I went out early.

I hope this finds you well—it leaves me feeling very well and getting very

black—and also getting so sure of my feet on the rocks that I am quite over feeling afraid I'll slip as I did at first—I can even surprise myself with the rough places I can get to bare footed. I have learned to wear the Japanese sandal with a string between the first and second toe—and worst of all in spite of what Japan may be doing I carry one of their paper umbrellas—

A kiss to you. Don't you think it would be nice to send my portfolio to the Jennings—you see I have been just visiting here and I want to do something for them. Would you have Andrew pack it and send it to

Willis Jennings
Hana, Maui
Territory of Hawaii—

They would be very pleased I know—Mrs. Jennings has cut my colored pictures out of Life and put them away specially—I hope you can get it off without too much trouble

Thursday March 23 – Wailuku
5 P.M.

I think it is the 23rd. How are you?

. . . [W]hen you write me that it is snowing and blowing and I can stand out in this rain that doesn't wet you I am glad I'm here—When I first came to Maui I wrote you about the beautiful green valley—Well—it is a wonderful valley—I've been painting up it for three days and it is just too beautiful with its sheer green hills and waterfalls—I should say mountains—not hills—a winding road that really frightens me—big trucks have to stop and back up to get round the curves but even if I'm scared it is worth it—you drive about ten miles an hour—it is just a narrow shelf on the side of the sheer mountain walls—I've borrowed a station wagon from the Sugar Plantation here—I am at Wailuku, Maui—Mr. Jennings and Patritia [sic] brought me down Monday—I hated to leave Hanna [sic] —it was something not like other places—really friendly—I felt at home—Monday night we were invited to a house half way up the volcano for dinner—it poured rain—the water about two inches deep on the walk to the house—Patritia [sic] and I took off our shoes and ran to the door—I felt a bit strange standing barefoot in the rain—shoes in hand being greeted by a woman I had never seen before—she dressed in quite elegant purple red velvet—huge open fire places with roaring fires—in all the

rooms—a house like nothing else I've seen—sort of elegant and free—but all held well in hand—

It was a very good evening—the mother I have heard much about was ill—I still hope to see her—Half way up the volcano is 4000 feet above sea level—40 miles up there—

Next morning Patritia [sic] and Mr. Jennings and I started for the volcano rim at 10 to four—dark of course—to see the sun rise—well—we didn't see anything but fog and rain and patches of snow—but on the way down in the day light the fields and hills and ocean and near islands all floated out in the clouds like a fairy story—it was very beautiful—

They left after lunch on Tuesday—I should have told you that the volcano rim we went up to is over 10,000 feet above sea level—it floats out there in the sky like a dream when I came out of my green valley....

I am glad I came—I could stay right here on this island for two or three months and like it—a country hotel that is comfortable—clean—food quite alright—nothing fancy—the people amuse me when I have time to walk down the street—there is a church I'd love to paint and wonderful trees—not many tourists.—There are cane fields—a sugar mill—I'd like to try to paint both—there is my green valley—and I haven't even started looking at the volcano—

Just a quiet little town—a bit quaint and queer—

Nice couple past middle age run the hotel—…

A kiss to you from this island I've hardly seen except in two spots—Am invited to drive around tomorrow—May go—

Saturday, March 25-Sunday, March 26 – Wailuku
On Maui Grand Hotel stationery

Isn't this paper grand?…

I have been painting away at a great pace—Have four paintings this week.… My paintings are all sharp green valleys with waterfalls. Today was very rainy so the valley is full of mists—It is queer to sit out there in the rain painting and not mind the rain till it really poured so hard I couldn't see much—then I finally packed up and came in—

I get up at about six—and go to bed early—last night right after supper—Am feeling fine—usually walk a little up to the valley—and again before supper around the town—so many oriental people make it different than any town I was ever in—

Makes me feel I ought to go on to Japan and China when I get this far—It

seems to be the next move I should make—. I guess I am drifting out in space a bit like the volcano.

You see Honolulu is really like the main land—this island seems to be drifting off in space some place I've never been and I seem to like it. It has an unchanging sort of feeling. . . .

A good night to you—I get sleepy so early it is funny—A soft little kiss to you Wish I could look in on you

<div style="text-align: right;">Sunday night 9:15</div>

Was out painting till 3 then drove up the volcano for the sun set—It is a long twisting drive—up through clouds to the top of the earth—nothing but rocks and clouds and some sort of red and golden earth piled in huge piles down inside the black crater—the wind is hard and damp and cold—in my winter coat and green shawl I was cold but it was worth it—sort of terrifying—separated from the earth by the vast mass of clouds—a spot of ocean in a couple of places—an edge of the island here and there—the sun setting—a small moon directly over head—really sort of unbelievable—Hawaiis three highest mountains rising out of the sea of cloud—one snow topped—no—not bad at all

A good night kiss to you

I'm tired

<div style="text-align: right;">Tuesday, March 28 - Wailuku</div>

In about three hours I am leaving Maui for Hawaii. I am sorry to go—I like it here—It is easy to get around as things that are very good are near by. I have five paintings—from Wailuku—two from Hana—A very good island—much more like an island than Oahu—I have such a fantastic flower that some one gave me yesterday—am taking it along—it is sort of dry and flat but lovely red and green and yellow—a variety of ginger—

The variety of landscape and weather on a little island like this is almost laughable—and all the changes are only a few miles away—

There are more Japanese than all the other nationalities put together— Well—they have chosen a good place. . . . I guess an island out here is a very long way from New York but I have liked it—am glad I came. . . . Some of the streets are so narrow—a car can barely get through them—

Yes it is a funny island

A kiss to you as I am leaving it

I go by boat over night—will be there early in the morning

I wonder and wonder about you

Untitled (*Hawai'i Landscape*), 1939
Georgia O'Keeffe
Graphite
4 1/4 x 7 1/4 in. (10.8 x 18.4 cm)
Georgia O'Keeffe Museum
Gift of The Georgia O'Keeffe
Foundation (2006.05.738)
© Georgia O'Keeffe Museum

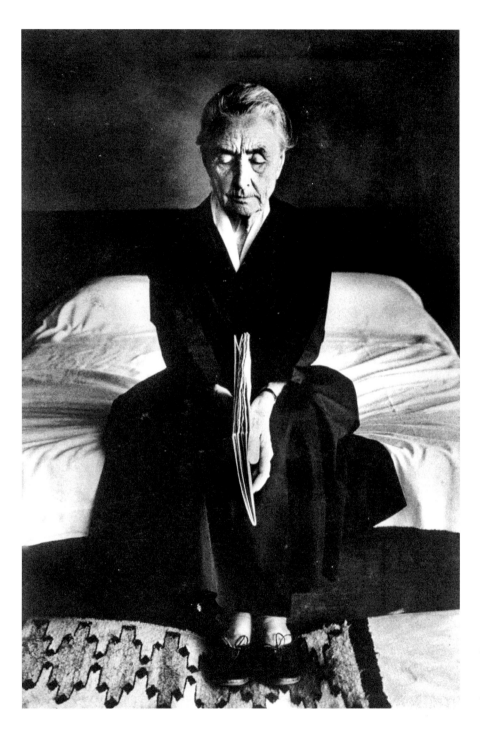

Georgia O'Keeffe, Abiquiu,
New Mexico, 1966
Photograph by John Loengard /
Time Life Pictures / Getty Images

AFTERWORD
Georgia O'Keeffe's Moons
James Meeker

My family and I spent most summers of the 1940s in New Mexico. We heard Georgia O'Keeffe's name often and saw her luminous paintings—the giant flowers captured my eight-year-old heart. As I grew older, I began spending more and more time in New Mexico and fell in love with the land and the people.

In 1980, my lady friend and I lived for a year in a cottage at the Hotel Hāna-Maui, amidst forty-five hundred acres of heaven. We had the run of the place, and I thank God to this day for such pleasure. One night, as I lingered in the hotel library, I saw a book on Georgia O'Keeffe and by chance opened to a page on which the word *Hāna* appeared. I'd heard that O'Keeffe came to Hawai'i to paint pineapples, and that evening I read that it had taken her nine days to get to Honolulu by train and ship. *My Hawaiian epiphany:* I could be in Hāna from Dallas in just nine hours—and at that moment decided to get a house there.

Two years later, in May 1982, I did purchase a home in Hāna—with large windows and glass doors that open onto the sea. I spent hours enjoying the mesmerizing surf, whales passing by, and on clear days, the Island of Hawai'i thirty miles away. I'd met Juan Hamilton, Georgia O'Keeffe's companion and protégé, some years earlier, and on the day I moved to Hāna, I ran into him at the hotel and invited him to come by if he had time.

Two days later, I saw Juan and Georgia O'Keeffe walking down my driveway! She had been the unwitting inspiration for my move, and now, at the age of ninety-four, she was coming by for a visit—her first time in Hāna since 1939. A housewarming surprise indeed! Dressed all in black, O'Keeffe cut an elegant figure as she walked toward the house twirling her long skirt like a dancer. She

passed a travelers palm, its three-foot stems crowned with white blossoms that look like a giant bird-of-paradise, and I'm certain I saw her glance at the flower despite her near blindness, which by then, I believe, gave her only peripheral vision.

Travelers palm flower.

My Hāna house had come furnished with a former ship captain's antiques, including four black lacquer chairs from China. Georgia sat on one of them and held court, beaming like the star that she was. She laughed as she pointed to the chair's rungs just a few inches above the floor, explaining that they allowed a person to keep his feet off the cold stone floors of China. Sipping tea from a small Chinese cup, she gracefully demonstrated how to hold it between the little finger and thumb to prevent the cup's heat from scalding you.

We moved to the grand couch, also from China, and looked out upon the sea. I sat next to her.

"How old are you?" she asked.

"Forty-six," I replied. She heard sixty-something.

"No, no, forty-six," I repeated.

She paused, patted my hand, and advised, "Don't worry, you won't hit your stride until you're fifty-five. Nobody does." Wisdom indeed.

We sat and talked throughout the afternoon, her conversation witty and wise. Her impeccable command of the language and her upright posture bespoke a woman of energy and elegance. At twilight, a rose-tinted moon began to rise out of the ocean and even with her dimming vision, she seemed to delight in the sight. We drove to the Hotel Hāna-Maui for dinner, and by the time we got there, the full moon was ablaze. Georgia continued to captivate us with her stories, the moon above the open-air dining area casting its magical light upon our table

The moon that night reminded me of one captured in a photo by Ansel Adams, one of O'Keeffe's great friends and admirers. As a college student, I saw Adams' photograph *Moonrise, Hernandez, New Mexico* and, appreciating the composition and feeling, decided to buy a print for my father's birthday. Being young and naive, I simply looked up the famous photographer in the Berkeley phone book, and Adams himself answered the phone. He readily agreed to sell me a print and shipped it out the next day. After it arrived in Texas—my dad was quite

Moonrise, Hernandez, New Mexico,
1941
Photograph by Ansel Adams
Collection Center for Creative
Photography, University of Arizona
© 2011 The Ansel Adams Publishing
Rights Trust.

pleased—I called Mr. Adams to find out the cost. "Oh, forget it," he replied. "I hope your father enjoys it."

A few years later, near the end of Georgia O'Keeffe's remarkable life, Juan Hamilton invited me to visit the sprawling compound of adobe houses in Santa Fe, where his family and O'Keeffe lived during her final years. Georgia was taking a nap and, through an open door, I caught a glimpse of her in her bed asleep, a benign prevailing presence. You can imagine my surprise when I saw Ansel Adam'

photo *Moonrise, Hernandez, New Mexico* on the entry wall of her sitting room. It must have been six feet wide and five feet high, the only art in the room.

I believe that Georgia O'Keeffe's great output in New Mexico was influenced by her visit to Hawai'i. Clearly, Hawai'i held a special place for her. You can see it in her letters; her exhibition statement ("If my painting is what I have to give back to the world for what the world gives to me, I may say that these paintings are what I have to give at present for what three months in Hawaii gave to me."); her words to Ansel Adams that visiting Hawai'i was one of "the best things I have done"; her special relationship with Patricia Jennings; and perhaps most of all, in her Hawai'i paintings.

For me, Hawai'i and New Mexico are two sides of the same enchanted coin. Both are exotic and paint-worthy, New Mexico with its high desert, unique and beguiling treasures, and a people as fine as the Hawaiians; Hawai'i with its giant flowers, lush vegetation, and soulful populace. Georgia O'Keeffe's Hawai'i paintings capture the beauty and essence of Hawai'i, which is the spirit of *aloha*. I felt it every day I lived in the Islands, and never more than the day I was blessed to sit with Georgia O'Keeffe under the full, rose-colored Hāna moon.

Georgia O'Keeffe with Juan Hamilton
and Agapita Judy Lopez, 1982
Unidentified photographer
Photographic print
3 1/2 x 4 1/2 in.
Georgia O'Keeffe Museum
Gift of The Georgia O'Keeffe Foundation
(2006-06-0814)
© Georgia O'Keeffe Museum

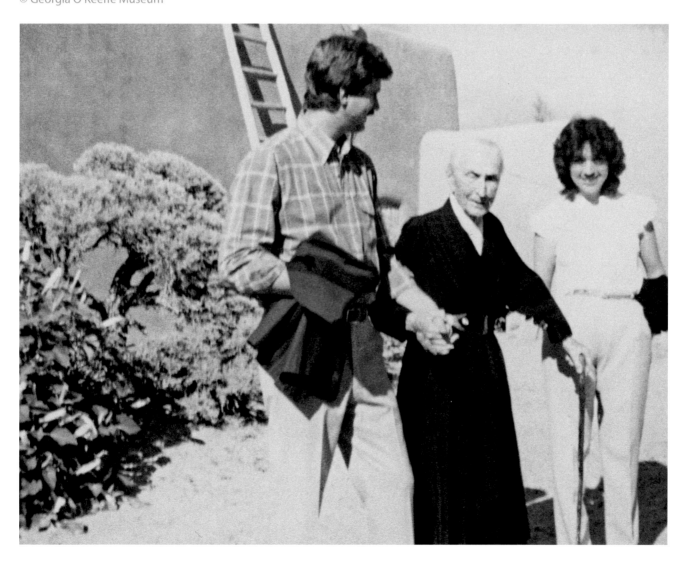

First Showing: A Dole Pineapple Bud from Hawaii

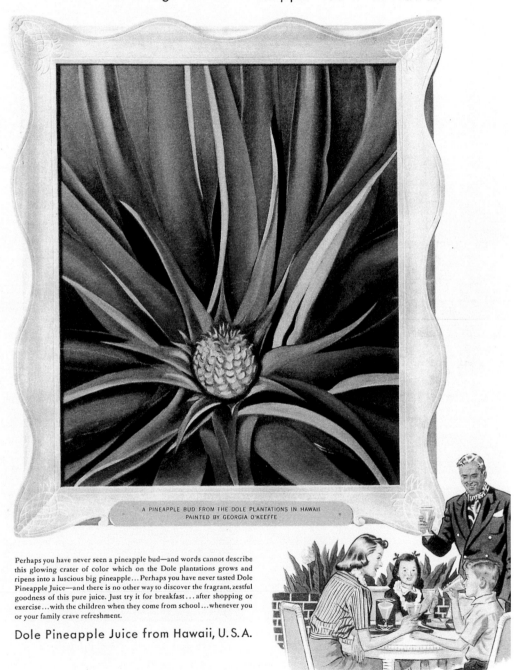

A PINEAPPLE BUD FROM THE DOLE PLANTATIONS IN HAWAII
PAINTED BY GEORGIA O'KEEFFE

Perhaps you have never seen a pineapple bud—and words cannot describe this glowing crater of color which on the Dole plantations grows and ripens into a luscious big pineapple...Perhaps you have never tasted Dole Pineapple Juice—and there is no other way to discover the fragrant, zestful goodness of this pure juice. Just try it for breakfast...after shopping or exercise...with the children when they come from school...whenever you or your family crave refreshment.

Dole Pineapple Juice from Hawaii, U.S.A.

● *Hawaiian Pineapple Company, Ltd., invited the world-famed American artist, Georgia O'Keeffe, to visit Hawaii and paint her impressions of the color and brilliance of the Islands. She chose the magnificent Haliconia flower, called by some the "Mock Bird of Paradise."*

PAINTED IN HAWAII, HOME OF DOLE PINEAPPLE JUICE, BY GEORGIA O'KEEFFE

Hospitable Hawaii cannot send you its abundance of flowers or its sunshine. But it sends you something reminiscent of both—golden, fragrant Dole Pineapple Juice. As you drink this pure, unsweetened juice of luscious, sun-ripened pineapples, you will know that only Nature could give Dole Pineapple Juice its marvelous flavor. For breakfast . . . when you are tired or thirsty between meals . . . whenever you, your children or guests crave refreshment, serve tall glasses of **DOLE PINEAPPLE JUICE FROM HAWAII**

NOTES

Unless otherwise noted, all correspondence cited in these notes and all quotes from Georgia O'Keeffe's letters throughout the book can be found in the Yale Collection of American Literature, Beinecke Rare Book and Manuscript Library, Yale University.

Introduction, by Jennifer Saville

Page

5 [Charles Coiner] selected upscale images: Quoted in Neil Harris and Martina Roudabush Norelli, *Art, Design, and the Modern Corporation,* exhibition catalogue (Washington, D.C.: National Museum of American Art, 1985), page 19.

I've been asked to do some work for a pineapple co.: Georgia O'Keeffe, in a letter to William Einstein, July 19, 1938, Lake George, New York. Reprinted in Jack Cowart, Juan Hamilton, and Sarah Greenough, *Georgia O'Keeffe: Art and Letters* (Boston: National Gallery of Art, Washington, D.C. in association with New York Graphic Society Books, Little, Brown and Company, 1987), page 229.

In 1924, [O'Keeffe] told her sister Catherine: Georgia O'Keeffe, in a letter to Catherine O'Keeffe [Klenert], February 8, 1924. Quoted in Roxana Robinson, *Georgia O'Keeffe: A Life* (New York: Harper & Row, 1989), page 265.

7 Ultimately she decided to take advantage of Dole's offer: Alfred Stieglitz, in a letter to William Einstein, January 30, 1939, New York.

Local newspapers noted the arrival of this "famous painter of flowers": "Famous Painter Of Flowers," in *Honolulu Advertiser*, February 12, 1939, Music, Art, Books, Drama Section, page 8.

A week later, O'Keeffe saw the pineapple fields: "O'Keeffe's Pineapple," *Art Digest* 17, number 11, March 1, 1943, page 17. Despite O'Keeffe's assertion to the *Art Digest* that it was two weeks before she saw a pineapple field, in a letter to Alfred Stieglitz postmarked February 17, 1939, Honolulu, she describes stopping at a pineapple field eight days after her arrival.

Hoping to placate their guest: "O'Keeffe's Pineapple," page 17.

9 One hostess took her to the Kapaʻa studio: Conversation with Reuben Tam, August 15, 1989.

Later, O'Keeffe wrote to Allerton and Gregg: Georgia O'Keeffe, in a letter to Robert Allerton and John Gregg, May 10, 1940, New York. Courtesy of National Tropical Botanical Garden, Kalāheo, Hawaiʻi.

11–12 In a letter to her friend Ettie Stettheimer: Georgia O'Keeffe, in a letter to Ettie Stettheimer, [March 1939, Wailuku, Maui].

12 She called on at least one local dignitary: While in Wailuku, O'Keeffe visited Judge Edna Jenkins. Conversation with Wilhelmina L. Markiewicz, daughter of Judge Jenkins, August 7, 1989.

It was there that young Patricia Jennings remembers: See Patricia Jennings, "Coming into Bloom: My Maui Adventures with Georgia O'Keeffe," page 67.

It is sixty miles in the country: Georgia O'Keeffe, in a letter to Alfred Stieglitz, [March 13, 1939, Hāna, Maui].

12-13 O'Keeffe's pleasure in visiting 'Īao Valley: Georgia O'Keeffe, letter to Ettie Stettheimer.

13 When I first came to Maui: Georgia O'Keeffe, in a letter to Alfred Stieglitz, March 23, [1939], Wailuku, Maui.

18 Reflecting on her time on Maui, she wrote: Georgia O'Keeffe, letter to Ettie Stettheimer.

On March 28, 1939, O'Keeffe boarded: Georgia O'Keeffe, in a letter to Alfred Stieglitz, [March 31, 1939, Kailua-Kona, Hawai'i].

They continued on to Kīlauea: Georgia O'Keeffe, in a letter to Alfred Stieglitz, [March 31, 1939].

19 She left the following day for the west side of the Big Island of Hawai'i: Georgia O'Keeffe, letter to Alfred Stieglitz, [March 31, 1939] and Richard Pritzlaff, telephone conversation with author, October 17, 1989.

Writing about the Island of Hawai'i: Georgia O'Keeffe, in a letter to Russell Vernon Hunter, October–November, 1939, New York. Reprinted in Cowart, Hamilton, and Greenough, page 229.

In a letter of May 3, 1939: Alfred Stieglitz, in a letter to Arthur Dove, May 3, 1939, New York. Reprinted in Anne Lee Morgan, ed., *Dear Stieglitz, Dear Dove* (Newark: University of Delaware Press), page 416.

20 O'Keeffe begrudgingly conceded: "Advertising Art Lures Brush of Miss O'Keeffe," *New York Herald Tribune*, January 31, 1940, page 10.

On July 11, Stieglitz noted: Alfred Stieglitz, in a letter to William Einstein, July 11, 1939, New York.

It is unclear which Hawaiian subject paintings she completed: Georgia O'Keeffe, *Georgia O'Keeffe: Exhibition of Oils and Pastels*, exhibition brochure (New York: An American Place, 1940).

27 The *New York World-Telegram* remarked: Hortense Saunders, "Eventful and Exciting Week in the World of Art," *New York World-Telegram*, February 10, 1940, page 28.

Henry McBride…noted: Henry McBride, "Georgia O'Keeffe's Hawaii," *New York Sun*, February 10, 1940, Art Section, page 10.

Stieglitz informed Eliot Porter: Alfred Stieglitz, in a letter to Eliot Porter, February 9, 1940, New York.

To the painter Arthur Dove, Stieglitz commented: Alfred Stieglitz, in letters to Arthur Dove, February 22 and 29, 1940, New York. Reprinted in Morgan, pages 431 and 433.

He summarized the exhibition: Alfred Stieglitz, in a letter to William Einstein, March 18, 1940, New York.

Despite her illness: Georgia O'Keeffe, in a letter to William Einstein, June 8, 1939, New York.

To her friend Russell Vernon Hunter: Georgia O'Keeffe, letter to Russell Vernon Hunter, October–November 1939.

She wrote to the photographer Ansel Adams: Georgia O'Keeffe, in a letter to Ansel Adams, July 8, 1958. Center for Creative Photography, University of Arizona, Tucson.

It is believed she fulfilled this wish: See Jennings, "Coming into Bloom," page 77.

29 O'Keeffe never commented specifically: Georgia O'Keeffe, *Georgia O'Keeffe* (New York: Viking Press, 1976), opposite plate 79.

Filling a space in a beautiful way: Georgia O'Keeffe, quoted in Mary Lynn Kotz, "Georgia O'Keeffe at 90," *Artnews* 76, number 10 (December 1977), page 37.

Coming Into Bloom, by Patricia Jennings

59 Dad, why don't we go to the Seven Pools: The *Maui News* and other sources have said that a Hotel Hāna-Maui employee made up the name Seven Sacred Pools in the 1950s. I don't know about the word "sacred," but we always called ʻOheʻo Gulch "the Seven Pools" when I was growing up in Hāna.

73 Robert W. Service, The Shooting of Dan McGrew (Boston: David R. Godine, Publisher, 1988), pages 1–24.

Georgia O'Keeffe's Letters from Maui—Pages 85–92

Comments by Patricia Jennings

In June 2011, after completing the writing of this book, I was delighted to discover the letters that Georgia O'Keeffe wrote from Hawaiʻi to her husband. It is obvious that visiting Hawaiʻi left a deep impression on her. In some cases, however, what she writes is simply not what happened. For example, she writes of swimming in a cave and diving under a ledge to another cavern, and it sounds as though she actually did it. It was something I described to her on our first day's outing. She also gives the impression of wading through streams. The one time my father and I took her hands to help her across a few inches of running water, her hands were trembling. She was terrified.

I find her not mentioning Harold or the von Tempskys interesting. Certainly I had the impression she liked Harold and Aunt Dora very

much—maybe not Alexa. The only mention of Harold comes as she was leaving Maui—the reference to a Danish man—Harold was from Denmark—and in a letter from Kona she refers to some bad snaps of her taken by Harold Stein. I am totally mystified by her reference to arriving for dinner barefooted to eat with a woman she had never seen before. She must mean Alexa; it sounds like her house.

Her description of my father is excellent. He was a gentle person in many ways, but he ran the plantation with a firm hand. It was the most important thing in his life. I found it interesting that the night harvesting made such an impression on her. Dad had started doing it a few months before her arrival. The workers liked it, as it was cooler, and Dad was pleased how well it was going. I'm amused that Lucky gets a mention: "There is also a dog."

I was not surprised to see her use of dashes. I clearly remember a conversation she had with Harold about punctuation. She said she found that a dash solved most of the problems of writing. I remember deciding at the moment it was a great idea—I have used it ever since.

We did receive a large leather portfolio of ten or twelve very nice prints of Georgia's paintings, and we still have them.

ACKNOWLEDGMENTS

Patricia Jennings Morriss Campbell

First of all, I must thank Jennifer Saville. I was living in Australia, and she phoned me there twice prior to writing the catalogue for the Honolulu Academy of Arts exhibit of Georgia O'Keeffe's Hawai'i paintings. I gave her a brief account of my time with Georgia and was happy to let the Academy use my photograph of Georgia as part of the catalogue. Reading this inspired Maria Ausherman to write me and suggest it be made into a book that might inspire adolescent readers. We wrote back and forth for several years, and I saw her in Honolulu whenever I was there. Over the years she wrote several versions, but finally I realized it must be in my words as I remember it. However, but for Maria's patient persistence, there would never have been a book. I really cannot thank her enough.

My sincere thanks to Margaret Simms, who reluctantly but expertly took photos of the Eskridge watercolors which were under glass, and my thanks to my son-in-law, Andrew Fisher, for photographing the Hāna watercolors in Honolulu. Matt Pearce, as usual, did a fine job of squaring the pictures and bringing them to life. My thanks to him and to my son Neil Morriss.

Lastly, my thanks to Arnie Kotler, who found my relationship with the famous artist interesting and worthy of print, and also realized that pictures would add much to the text. He and Maria Ausherman patiently pursued the owners of Georgia O'Keeffe's Hawai'i work, so that reproductions of her beautiful Island pictures could be included.

Maria Ausherman

Many people inspired me along the way, all of whom were touched by Patricia's remarkable story. Charlene Gilmore, a friend and talented writer, spent hours with me observing Georgia O'Keeffe's paintings at the Honolulu Academy of Arts and accompanied me to Maui to learn more about that island. Together we

daydreamed about the structure of the story. Jennifer Saville kindly forwarded my first letter to Patricia Jennings and allowed us to draw from her exhibition catalogue for the introduction to this volume. Members of the Writers Voice, a New York City writing group, especially Glenn Raucher, the director, and Mindy Lewis, a gifted instructor, encouraged me to keep the story personal. Arnie Kotler shared my enthusiasm for this story, worked closely with Patricia and me on the text, and was determined to include O'Keeffe's Hawai'i paintings.

I thank my daughters for their eternal love, cheerfulness, and great sense of humor. Most of all, they remind me that children have unique ways of seeing and that we need not only to protect their points of view, but help them appreciate these riches. Chloe, as a young goalie of her soccer team, would find four-leaf clovers while her teammates were down the field attempting to score. Although she is an amazing soccer player, observing the small plants was more important to her than winning the game. Lydia illustrated the first draft of this book on handmade rice paper. Her watercolors included Georgia O'Keeffe stepping off the *Lurline* in Honolulu, O'Keeffe wearing a flower lei, hibiscus blossoms, a papaya tree, a pineapple, heliconia, Maui landscapes, pineapple field workers, and the Dole pineapple factory. Thanks to her interest and meticulous renderings, this project began as a picture book for young children.

I am grateful to my parents, Charles and Rieneke, for their enduring support; to Mary Jane Chapman for listening to me recount the progress of my efforts and for giving me worthwhile advice; and to Steven Taylor for his technical expertise and everlasting friendship.

Arnie Kotler, Editor

I was touched when I first read this manuscript about Patricia Jennings' time with Georgia O'Keeffe. It has been a pleasure to work closely with Patricia and Maria on this book, receiving help as well from writers Tom Peek, Wayne Moniz, Helen Bigelow, Jill Engledow, and Peggy Lindquist, and input from interns Paul Yellin, Noelle Aviles, Emily and Lacey Farm, Alexandria Agdeppa, Kalani Ruidas, Nicole Ka'auamo, and Amanda Lee. Therese Fitzgerald entered hard-copy edits on the computer and offered incisive insights. Frances Bowles proofread the

book meticulously and created the index that follows. Special thanks to Barbara Pope for generously sharing her time and experience, and to James Meeker for writing the afterword.

Deep thanks to the LEF Foundation, the Atherton Family Foundation, and James Meeker for crucial support, and to the Georgia O'Keeffe Museum and the owners of O'Keeffe's Hawai'i paintings for permission to reproduce these works. Sincere appreciation to Agapita Judy Lopez for reading the page proofs on behalf of the Museum. Thanks to Joan Halifax and Natalie Goldberg for efforts on behalf of this project. I especially wish to thank Kathee Hoover, gift shop manager of the Honolulu Academy of Arts, who was available to answer questions at every turn; Pauline Sugino who graciously offered permission to reproduce the Academy's five O'Keeffe Hawai'i paintings; Shuzo Uemoto, who provided high-resolution scans; and Jennifer Saville and the Academy for allowing us to adapt the introduction from the catalogue that accompanied their 1990 exhibition of Georgia O'Keeffe's Hawai'i paintings.

Thanks to Mark Vierra and the team at onthemark for extraordinary attention to detail printing this volume. And most of all, profound thanks to Lisa Carta, the designer of this book, for going so many extra miles to bring *Georgia O'Keeffe's Hawai'i* the beauty and depth it deserves.

ABOUT THE AUTHORS

Patricia Jennings Morriss Campbell with her great-grandchildren.

PATRICIA JENNINGS MORRISS CAMPBELL grew up in Hawaiʻi and lived in St. Louis for seventeen years with her husband William Morriss and their children. They returned to Hawaiʻi in 1962, where she served on the boards of numerous art and charitable organizations and managed a macadamia plantation and a general store. After eleven years as a widow, she married Allan Campbell and experienced life in the Australian bush. She is presently living in Kamuela on the Big Island of Hawaiʻi.

Maria Ausherman

MARIA AUSHERMAN lived for twelve years in Hawaiʻi, where her daughters attended Punahou and the Mid-Pacific School of the Arts. She completed her B.A. in Geography from the University of North Carolina in Chapel Hill; received an M.A. in Cinema Studies from the City University of New York; and an M.Ed. in Social Science Education from the University of Georgia in Athens, where she also obtained a graduate certificate in historic preservation and completed coursework and a dissertation for a Ph.D. in Art. She is author of *The Photographic Legacy of Frances Benjamin Johnston* and currently teaches global studies, American history, civics, and economics in New York City.

ABOUT THE CONTRIBUTORS

JENNIFER SAVILLE is the former curator of Western art at the Honolulu Academy of Arts. She curated the 1990 exhibition of Georgia O'Keeffe's Hawai'i paintings and is author of *Georgia O'Keeffe: Paintings of Hawai'i* and *John Taylor Arms: Plates of Perfect Beauty*, and coauthor of *Finding Paradise: Island Art in Private Collections, A Printmaker in Paradise: The Art and Life of Charles W. Bartlett,* and *The American Canvas: Paintings from the Collection of the Fine Arts Museums of San Francisco*. She lives in Honolulu.

JAMES MEEKER graduated from Dartmouth College with honors in creative writing. He attended Stanford Law School and Graduate School in English, and for seven years was Fine Arts Editor and a weekly columnist for the *Fort Worth Star-Telegram*. He worked with the Kimbell Art Foundation and Museum and the Amon Carter Museum, and served on the boards of Dartmouth's Hopkins Center for the Arts, the Spoleto Music Festival,the Modern Art Museum of Fort Worth, and the Restoration of El Santuario de Guadalupe in Santa Fe. He is the Principal in Meeker Investments & Trust, and founder and board member of Adopt A Special Kid (AASK).

INDEX

ABOUT KOA BOOKS

Koa Books publishes works that foster a deeper understanding of
personal transformation, social justice, and Hawai'i.
For more information, please visit
www.koabooks.com